30-65 P2K 30-4

001

CHARLESTON
12 KILOTONS
NEVADA
1957

100 SUNS

1945–1962

MICHAEL LIGHT

ALFRED A. KNOPF NEW YORK 2003

DESERT

002

MOTH
2 KILOTONS
NEVADA
1955

003

HARRY
32 KILOTONS
NEVADA
1953

004 **HORNET** 4 KILOTONS NEVADA 1955

005 HOW 14 KILOTONS NEVADA 1952

006 TRINITY 21 KILOTONS NEW MEXICO 1945

007 APPLE-1 14 KILOTONS NEVADA 1955

008

STOKES
19 KILOTONS
NEVADA
1957

009

WHEELER
197 TONS
NEVADA
1957

010

FRANKLIN PRIME
4.7 KILOTONS
NEVADA
1957

011

LAPLACE
1 KILOTON
NEVADA
1957

012

STOKES
19 KILOTONS
NEVADA
1957

013

STOKES
19 KILOTONS
NEVADA
1957

015

SUGAR
1.2 KILOTONS
NEVADA
1951

016

ZUCCHINI
28 KILOTONS
NEVADA
1955

017

FOX
11 KILOTONS
NEVADA
1952

018

HOOD
74 KILOTONS
NEVADA
1957

019 SIMON 43 KILOTONS NEVADA 1953

020　**FIZEAU**　11 KILOTONS NEVADA 1957

021

CLIMAX
61 KILOTONS
NEVADA
1953

022

HORNET
4 KILOTONS
NEVADA
1955

023/024 SMOKY 44 KILOTONS NEVADA 1957

025

DIABLO
17 KILOTONS
NEVADA
1957

026 **WHITNEY** 19 KILOTONS NEVADA 1957

027 SHASTA 17 KILOTONS NEVADA 1957

031

APPLE-1
14 KILOTONS
NEVADA
1955

032

PRISCILLA
37 KILOTONS
NEVADA
1957

033/034 **PRISCILLA** 37 KILOTONS NEVADA 1957

035

PRISCILLA
37 KILOTONS
NEVADA
1957

037 ZUCCHINI 28 KILOTONS NEVADA 1955

038

MET
22 KILOTONS
NEVADA
1955

039 DOG 21 KILOTONS NEVADA 1951

040

DOG
21 KILOTONS
NEVADA
1951

M289-10

042

EASY
31 KILOTONS
NEVADA
1951

30-006-ATIED/APS-55-2579

30-0006-AT160/APS-55-2588

045

STOKES
19 KILOTONS
NEVADA
1957

30-65 PLK 233-3

795-11 NTS 62 4FPR

046

LITTLE FELLER
18 TONS
NEVADA
1962

048

HOOD
74 KILOTONS
NEVADA
1957

26194-609/AM-57

OCEAN

050

X-RAY
37 KILOTONS
ENEWETAK ATOLL
1948

051

X-RAY
37 KILOTONS
ENEWETAK ATOLL
1948

052

YOKE
49 KILOTONS
ENEWETAK ATOLL
1948

054 ERIE 14.9 KILOTONS ENEWETAK ATOLL 1956

259353

056

ABLE
21 KILOTONS
BIKINI ATOLL
1946

057

BAKER
21 KILOTONS
BIKINI ATOLL
1946

6 DBCR

1(U)-178-403/25 JULY 46/20"/OBL/12,000'/BIKINI/

059 BAKER 21 KILOTONS BIKINI ATOLL 1946

060 SEMINOLE 13.7 KILOTONS ENEWETAK ATOLL 1956

061

HURON
270 KILOTONS
ENEWETAK ATOLL
1956

062

SEQUOIA
5.2 KILOTONS
ENEWETAK ATOLL
1958

063

KING
500 KILOTONS
ENEWETAK ATOLL
1952

064 DOG 81 KILOTONS ENEWETAK ATOLL 1951

065

MIKE
10.4 MEGATONS
ENEWETAK ATOLL
1952

066

MIKE
10.4 MEGATONS
ENEWETAK ATOLL
1952

067

MIKE
10.4 MEGATONS
ENEWETAK ATOLL
1952

068

MIKE
10.4 MEGATONS
ENEWETAK ATOLL
1952

069

MIKE
10.4 MEGATONS
ENEWETAK ATOLL
1952

26EAK1-12

070 MIKE 10.4 MEGATONS ENEWETAK ATOLL 1952

071/072 **OAK** 8.9 MEGATONS ENEWETAK ATOLL 1958

073

MAGNOLIA
57 KILOTONS
ENEWETAK ATOLL
1958

074 YESO 3 MEGATONS CHRISTMAS ISLAND 1962

075

YESO
3 MEGATONS
CHRISTMAS ISLAND
1962

076

WAHOO
9 KILOTONS
ENEWETAK ATOLL
1958

077

STARFISH PRIME
1.4 MEGATONS
JOHNSTON ISLAND
1962

079

ORANGE
3.8 MEGATONS
JOHNSTON ISLAND
1958

080

BLUESTONE
1.27 MEGATONS
CHRISTMAS ISLAND
1962

26-15057-62 STF-8 UFPR

082

HARLEM
1.2 MEGATONS
CHRISTMAS ISLAND
1962

083 CACTUS 18 KILOTONS ENEWETAK ATOLL 1958

084 YELLOWWOOD 330 KILOTONS ENEWETAK ATOLL 1958

085

FRIGATE BIRD
600 KILOTONS
CHRISTMAS ISLAND
1962

086

MOHAWK
360 KILOTONS
ENEWETAK ATOLL
1956

087　MOHAWK　360 KILOTONS　ENEWETAK ATOLL　1956

088 ZUNI 3.5 MEGATONS BIKINI ATOLL 1956

089 AZTEC 410 KILOTONS CHRISTMAS ISLAND 1962

091 APACHE 1.85 MEGATONS ENEWETAK ATOLL 1956

092　CHEROKEE 3.8 MEGATONS BIKINI ATOLL 1956

093 BRAVO 15 MEGATONS BIKINI ATOLL 1954

094 **SUNSET** 1 MEGATON CHRISTMAS ISLAND 1962

095

ROMEO
11 MEGATONS
BIKINI ATOLL
1954

096

ROMEO
11 MEGATONS
BIKINI ATOLL
1954

097 DAKOTA 1.1 MEGATONS BIKINI ATOLL 1956

098 APACHE 1.85 MEGATONS ENEWETAK ATOLL 1956

099 BRAVO 15 MEGATONS BIKINI ATOLL 1954

100

YANKEE
13.5 MEGATONS
BIKINI ATOLL
1954

A NOTE ON THE PHOTOGRAPHS

The images in this book show U.S. atomic detonations from the era of above-ground nuclear testing, which lasted from July 16, 1945 to November 4, 1962. In that time, the United States conducted 216 nuclear tests in the atmosphere and oceans, and the Soviet Union conducted 217. After both countries signed the Limited Test Ban Treaty on August 5, 1963, nuclear testing in the atmosphere, the oceans, and cosmic space ceased. Thereafter, both nations vigorously pursued nuclear testing underground. The United States would go on to perform a total of 1054 nuclear tests, involving 1149 separate explosions, until its last test occurred on September 23, 1992. The Soviet Union would conduct a total of 715 tests, involving 969 separate explosions, until its last test event on October 24, 1990. That nation would formally dissolve 13 months later.

Since their inception, nuclear weapons have been used twice in combat. On August 6, 1945, the United States dropped a bomb with a yield of 15 kilotons – the destructive force of 15,000 tons of TNT – on the Japanese city of Hiroshima, eventually killing over 200,000 people. Four days later the United States destroyed the Japanese city of Nagasaki with a bomb yielding 21 kilotons; over 60,000 people would eventually die. Japan agreed to unconditional surrender five days later, and World War II ended shortly thereafter.

A nuclear weapon is a device in which explosive energy is derived from either fission, fusion, or a combination of the two. Nuclear fission is the splitting of the nucleus of a large atom into two or more parts, and was first demonstrated in an explosive device in 1945 with the *Trinity* test, which yielded 21 kilotons. When bombarded by neutrons, some atoms of extremely heavy elements – such as those of the isotope uranium-235, which forms about 0.7% of naturally occurring uranium, and those of plutonium-239, which does not occur naturally and is instead made in nuclear reactors – will fall apart. This fission releases lighter nuclei, energy and neutrons, and the neutrons produced can then go on to split further atoms in an ever-increasing chain reaction. Nuclear fusion is the forcing together of the nuclei of two light atoms to create a third, and was first demonstrated in an explosive device in 1952 with the *Mike* test. *Mike* yielded 10,400 kilotons, or 10.4 megatons, of energy, 500 times the power of *Trinity* and more than that released in all the explosions of both world wars combined. To create the conditions under which deuterium and tritium, which are heavy isotopes of hydrogen, will fuse to form helium requires conditions of extreme heat and pressure that can only be achieved by using a first fission explosion as an "initiator". These hydrogen bombs, or thermonuclear weapons, thus come in two stages, with fission components triggering fusion components. In some designs a third stage, in which neutrons from the fusion set off yet more fission, is added.

Fission and fusion differ in the amount of energy that they release. Splitting every atom in one gram of uranium-235 would release 12.5 million times more energy than would be given off by a gram of ordinary chemical explosive; fusing one gram of deuterium into helium would release eight times more energy still. A further difference between fission and fusion explosions is that the former are self-limiting. Fission depends on the assembly of a "critical mass" in which there are enough atoms, closely enough compressed, for a chain reaction to get underway. The subsequent explosion quickly disassembles this critical mass, and the fission reactions thus cease. For this reason the largest fission devices – which are "boosted" with the addition of some heavy hydrogen – have a maximum yield of about one megaton. A true fusion explosion does not depend on a critical mass in the same way; it will burn as brightly and as long as it has access to thermonuclear fuel. That there are no inherent upper physical limits to the size of a fusion explosion is demonstrated by the stars, which are thermonuclear furnaces thousands and even millions of times larger than the earth.

A nuclear explosion creates damaging heat and blast effects like those of a conventional explosion, though on a far greater scale. In a hundred-millionth of a second, the temperature at its core builds to several hundred million degrees, many times the temperature of the center of the Sun, and pressures reach a hundred million atmospheres, creating initial expansion speeds of about five million miles an hour. But a nuclear explosion also transforms the very fabric of matter, producing gamma-rays, X-rays and radio waves as well as neutrons, alpha particles and beta particles. All this radiation is undetectable by human senses and some of the emissions – X-rays, gamma-rays, and neutrons in particular – can penetrate living tissue and alter the delicate structure of its cells. In some cases this radiation will kill cells outright, in some cases it will damage in a way that can be coped with and repaired, and in some cases it will damage their genetic material so that the cells go on to reproduce imperfectly and without check. This last possibility is the one that causes cancer, sometimes relatively quickly after exposure to the radiation, sometimes decades thereafter.

As well as releasing vast amounts of energy, nuclear devices also create a host of unstable radioactive isotopes, both by burning their own nuclear fuel and by irradiating material close to the explosion. These unstable isotopes will eventually decay into stable isotopes; the radiation they give off is part of this process. The rate of decay is defined by the isotope's "half-life" – the time it takes for half a given amount of the material to decay. Some radioactive isotopes have half-lives of seconds, some of years, some of centuries. Thus the invisible legacy of a nuclear explosion can linger long after detonation, both in the environment at large and in the bodies of living things.

This radioactive aftermath can be spread out in space, as well as time. The term "fallout" refers to the return to earth of radioactive matter which has been lifted into the atmosphere by a nuclear detonation, as well as the matter itself once it is deposited on the ground, vegetation, structures, or a body of water. Detonations which occur very high in the atmosphere or underground produce little or no fallout, while those occurring near the surface of the earth produce a great deal, as vast quantities of dirt, dust and smoke are thrown into the air by the blast and irradiated. Depending on the prevailing winds, the radioactive debris cloud of a nuclear detonation can travel for hundreds and even thousands of miles, sprinkling the earth evenly with fallout or concentrating in "hot spots" caused by rain or snow bringing many radioactive particles down at once.

Some radioactive fission isotopes are more dangerous to humans than others. Within the first month, the most harmful are iodine-131, with a half-life of 8 days, and strontium-89, with a half-life of 54 days. Longer term, strontium-90, with a half-life of 25 years, and cesium-137, with a half-life of 33 years, are the greatest hazards. The body treats radioactive iodine and cesium the same way it processes regular iodine and potassium, so they concentrate in the same organs, particularly the thyroid, where cancers are likely to form. Infants and children are particularly at risk, since the milk of cows that have grazed on fallout-covered pasture will contain the dangerous isotopes in concentrated form. Similarly, the body treats radioactive isotopes of strontium as if they were normal calcium, passing them to the bone and marrow, where they are likely to cause leukemia.

Of the 216 atmospheric tests detonated by the United States, 106 of them occurred continentally at the Nevada Test Site, 63 miles from Las Vegas. The footprint of harmful radioactive fallout from those detonations flowed generally to the east and northeast of the test site, often extending the length of the nation and occasionally into the Atlantic Ocean beyond. Those areas immediately east and north of the test

site in Nevada and Utah were hardest hit throughout the 1950s and early 1960s, though the U.S. government attempted to minimize public perception of the danger through a systematic campaign of propaganda and intimidation. Finally realizing the full extent of the adverse health effects they suffered from continental tests, "downwinder" residents of these areas organized in the 1970s, and by the early 1990s had extracted a formal apology from Washington, as well as ongoing monetary compensation for a host of fallout-related cancers.

From 1951 to 1957 at the Nevada Test Site, U.S. military troops, primarily from the Army, were ordered to observe nuclear tests at varying distances from the blast point, and then conduct "atomic war exercises" at or near ground zero immediately after detonation. Sometimes they were placed in trenches as close as 1.8 miles away. While the personnel safety guidelines of the Atomic Energy Commission – the civilian agency in charge of United States nuclear matters – required a distance of 7 miles from the blast, the U.S. military quickly bypassed them in its quest to create "hardened" troops capable of "tactical" warfare on the atomic battlefield. Many nuclear test veterans contracted fatal cancers and died; those that survived long enough to organize, like downwinder residents, would receive official governmental recognition of their plight and monetary compensation beginning in 1988.

While the U.S. military did not conduct troop exercises during the higher-yielding nuclear tests conducted at isolated atolls and islands in the Pacific from 1946 to 1962, the human cost of the tests was, and continues to be, steep. Indigenous islanders were uprooted without recourse from test site areas initially, and several tests greatly exceeded expected yields, creating intense and unexpected radiological disasters. Of these, the 15-megaton 1954 *Bravo* test at Bikini Atoll in the Marshall Islands was the worst, badly sickening test personnel, relocated islanders nearby, and the crew of a Japanese fishing vessel 85 miles away from the blast. Repeated large-scale testing has also resulted in enduring radiological contamination of all the test islands, including Enewetak Atoll and Johnson and Christmas Islands. Bikini remains uninhabitable to this day, its soil contaminated with radioactive cesium-137 which concentrates in fruits and vegetables. Like the Nevada downwinders, the Bikinians organized and eventually sued the United States for damages; in 1982 the U.S. established three trust funds for environmental restoration and reparations, also creating a fund for the restoration of the southern islands of Enewetak Atoll as well. Enewetak has been successfully restored and resettled. In 1988 the United States established a Marshallese Nuclear Tribunal to compensate radiation victims, and more than 1000 islanders have received damages.

* * *

The photographs in *100 SUNS* depict U.S. nuclear tests at or near the moment of detonation, and most were declassified by the U.S. government shortly after test completion. The United States usually announced atmospheric tests in advance, and images that did not reveal the size, shape, weight or inner workings of a nuclear device were released to the public, often to underscore to domestic and international audiences the power or innovation of a particular test. Most of the images seen here were obtained from prints at the U.S. National Archives, with a few gleaned from the records of the Los Alamos National Laboratory. They have been reproduced here with faithfulness to the appearance of the particular print.

Each of the 1054 U.S. nuclear tests was given a code-name by either the U.S. military or the Atomic Energy Commission. Names were initially based on the military phonetic alphabet (Able, Baker, Charlie, and so forth), but quickly branched out into more arbitrary and eclectic nomenclature to avoid duplication and confusion. Test names were never indicative of the nature of the actual classified nuclear device or weapon at hand.

While 22 images in this book were made by photographers in the U.S. Army Signal Corps, most are the work of the 1352nd Photographic Group of the U.S. Air Force.

From 1947 to 1969, the 1352nd Photographic Group was based at an extensive motion picture and still photographic facility in Hollywood, California called the Lookout Mountain Air Force Station. Lookout Mountain was thus in a position to draw on the world's best film technology and its largest relevant talent pool, while protecting top-secret classified military information in a dedicated, essentially clandestine complex.

The Station was charged with photographing and filming all aspects of U.S. nuclear tests at the Nevada Test Site and the offshore Pacific Proving Grounds. Using onsite studio and lab facilities, Lookout's civilian and military staff also produced over 6500 scientific, technical, training and informational films for the Air Force, Department of Civil Defense, Atomic Energy Commission, and other U.S. government agencies. Some were released early on as propaganda; many are still classified.

The Lookout Mountain cameramen generated vast amounts of visual documentation of each test, bringing their manned cameras as close as 4 miles to the point of detonation in Nevada and operating remotely-controlled ones closer. During the much larger Pacific tests, they kept their manned cameras a minimum of 20 miles from the blast point. Aside from recording history, their photographic work was integral to scientific investigation of the tests. Measuring the yield of a detonation, for example, was done three ways: by "bang-meters" on the ground, by multiple cameras filming throughout, and – most accurately – by radiochemical analysis.

Only a small fraction of the extensive documentation of nuclear tests by Lookout Mountain and the Army Signal Corps can now be found in publicly accessible U.S. government archives. It is not the purpose of this work to try to locate that hidden mass of material, much of which may have been lost, deliberately destroyed, or remain classified. In some ways, however, the archive images that are available do speak more of absence than of presence. One cannot help but wonder what as citizens we still do not know about the subject of nuclear weapons, not only in the sense of the surreal excesses of the Cold War past, but in terms of the hidden, weaponized nuclear present that will be with us for as long as we know time.

While eliminating the global specter of radioactive fallout and perhaps somewhat moderating the nuclear saber-rattling of nations, the shift to exclusively underground testing brought about by the 1963 Limited Test Ban Treaty came at a paradoxically high price: cultural invisibility and secrecy. The United States has detonated four times as many nuclear detonations underground as it has above. In all of these underground tests, there has been little to see and little to photograph; there is no record that helps keep an informed citizenry viscerally aware of what its government is doing. While the world is currently not locked in a nuclear arms race between superpowers that in hindsight can only be described as a kind of state-level psychosis, these "weapons of mass destruction" are with us forever. Their proliferation continues apace, and they are held redundantly in the most numbers by the United States.

It is difficult to comprehend the mechanics and effects of just one such distillation of brilliant human savagery, much less the some hundred thousand nuclear weapons that have been fabricated by nations since the *Trinity* test. Any conscious person instinctively turns away. That is why these photographic images from the era of atmospheric nuclear detonation remain utterly relevant, beyond the historic interest of the extreme moment they capture. Photographs only tell us about the surface of things, about how things look. When it's all we have, however, it's enough to help understanding. It exists. It happened. It is happening. May no further nuclear detonation photographs be made, ever.

Michael Light

CAPTIONS

Front dust jacket: **SUGAR**, Operation JANGLE (see #015).
Rear dust jacket: **STOKES**, Operation PLUMBBOB (see #008).
Boards: Front: **X-RAY**, Operation SANDSTONE, detail (see #050). Back: **MIKE**, Operation IVY (see #065).

001. **CHARLESTON**, Operation PLUMBBOB. 6:00am September 28 1957, Nevada Test Site, balloon detonation at 1500', yield 12 kilotons. Hanging from its spot-lit balloon in the predawn darkness, *Charleston* will shortly be lofted to blast height. A small, tactical two-stage thermonuclear weapon expected to yield 50-100 kilotons, *Charleston* "fizzled" when its fusion second stage failed to ignite. Had it done so, it would have been the third true thermonuclear test on the continental United States, though the Federal Government and the Atomic Energy Commission denied for decades that any such "H-bomb" devices had ever been detonated in Nevada. *Charleston*'s radioactive debris cloud rose to a height of 27,800'. Image by U.S. Air Force 1352nd Photographic Group, Lookout Mountain Station.

002. **MOTH**, Operation TEAPOT. 5:45am February 22 1955, Nevada Test Site, tower detonation at 300', yield 2 kilotons. With U.S. Army soldiers in trenches only 2.3 miles away from ground zero, *Moth* vaporizes its tower, creating intense radioactivity of 500 roentgens/hour 900' north of the blast. At 445 pounds, it was the lightest nuclear weapon detonated to date. *Moth* was an un-boosted prototype test of what would become the W-30 warhead, an air-defense and tactical weapon that was stockpiled from 1959 to 1979 with a variable yield of 140 tons to 19`kilotons (see *Hornet*, #s 004 and 022, for a boosted test of the same weapon). Despite its small size, *Moth* was seen as an orange flash in the sky as far away as San Francisco. Its radioactive debris cloud rose to a height of 24,200' before spreading fallout across the entire United States and the Atlantic Ocean beyond. Image by Sergeant James R. Covington, U.S. Army Photographic Signal Corps.

003. **HARRY**, Operation UPSHOT-KNOTHOLE. 4:05am May 19 1953, Nevada Test Site, tower detonation at 300', yield 32 kilotons. Photographed by an automatic ultra high-speed camera, *Harry*'s fireball is frozen approximately 0.0001 seconds after detonation, before the blast has engulfed its tower. The surface mottling and irregularity is a result of high-velocity bomb debris "splashing" against the backside of the slightly slower expanding fireball, which glows due to compression heating of the surrounding air. *Harry* tested a device designed by nuclear miniaturization expert Ted Taylor that resulted in the most efficient low-yield fission detonation ever. "Dirty Harry" was also a radiological disaster, creating the worst fallout contamination of any of the U.S. continental atmospheric nuclear tests. 1000 troops observed the fireball, which lasted an unusually-long 17 seconds; the radioactive debris cloud rose to a height of 38,000' and then moved directly over St. George, Utah, 100 miles to the east. Deadly fallout inundated the entire town of 5000 innocent and unsuspecting residents, most of whom would later develop cancer. The Hollywood film *The Conqueror*, starring John Wayne and Susan Hayward, was shot the following summer in a canyon near St. George; 30 years later, 91 members of the cast of 220 had developed various cancers, and Wayne and Hayward would both die of it. Of the estimated cumulative total of 85,000 person-roentgens of external gamma ray exposure created by all continental tests from 1951 to 1958, *Harry* is thought to have contributed 30,000 alone. Fallout from three other tests in the Operation Upshot-Knothole series would prove especially deadly as well: *Nancy*, detonated on March 24, would kill 4390 sheep near Cedar City, Utah; *Dixie*, detonated on April 6, would cover Boston with radiation, and *Simon* (see #019), detonated April 25, would douse Albany, New York with unsafe levels of radioactive rain. Shortly after the Operation's conclusion a Utah Congressman demanded that all testing on the continental United States stop; public concerns about the dangers of fallout began to coalesce as a national issue. The Atomic Energy Commission publicly maintained until its dissolution in 1974 that no damage was done from either *Harry* or *Nancy*; internal documents declassified thereafter showed this to be a patent lie. Image from an Edgerton, Germeshausen, & Grier *Rapatronic* camera by U.S. Air Force 1352nd Photographic Group, Lookout Mountain Station.

004. **HORNET** (probable), Operation TEAPOT (see also #022). 5:20am March 12 1955, Nevada Test Site, tower detonation at 300', yield 4 kilotons. In an automatic ultra high-speed exposure made about 0.0003 seconds after detonation, *Hornet*'s fireball almost completely engulfs its tower. The tripod-like "legs" of fire stretching to the ground result from the tower cables absorbing thermal radiation from the fireball; at this point the temperature at the core of the fireball exceeds 100 million degrees – 10 times hotter than the sun's core – and its visible light is about 100 times brighter. *Hornet* was a boosted-prototype test of what would become the W-30 warhead, an air-defense weapon that was stockpiled from 1959 to 1979 with a yield of 140 tons to 19 kilotons. Image from an Edgerton, Germeshausen, & Grier *Rapatronic* camera by U.S. Air Force 1352nd Photographic Group, Lookout Mountain Station.

005. **HOW**, Operation TUMBLER-SNAPPER (see also #014). 3:55am June 5 1952, Nevada Test Site, tower detonation at 300', yield 14 kilotons. Photographed by an automatic ultra high-speed camera 0.0008 seconds after detonation, *How* shows surface mottling and expanding cable fire spikes as it engulfs its tower and expands outwards. *How* was a developmental test of Ted Taylor's small, light, high-compression device that used a revolutionary beryllium tamper; Taylor lit his cigarette with the detonation light focused in a parabolic mirror. *How* became the Mark-12 bomb, a jet fighter-carried tactical weapon yielding 12 to 14 kilotons that was stockpiled from 1954 to 1962. Image from an Edgerton, Germeshausen, & Grier *Rapatronic* camera by U.S. Air Force 1352nd Photographic Group, Lookout Mountain Station.

006. Project **TRINITY**. 5:30am July 16 1945, Alamagordo Bombing Range, Jornado del Muerto desert, New Mexico, tower detonation at 100', yield 21 kilotons. Caught by an ultra-high speed camera 0.053 seconds after detonation, the world's first nuclear explosion expands six miles away, vindicating the Manhattan Project. At this point, *Trinity*'s fireball has reached 853' in diameter and shows a hemispherical front with an irregular "dust-skirt" caused by the very fast ground wave moving over the desert floor. The diagonal line to the right of the image is a cable anchoring a barrage balloon above. *Trinity* was a plutonium-fueled, implosion nuclear device. After detonation Manhattan Project Director J. Robert Oppenheimer quoted the Bhagavad-Gita, the classic Vedic text, with the words "If the radiance of a thousand suns were to burst forth at once in the sky, that would be like the splendor of the Mighty One … I am become Death, the destroyer of worlds." To dispel rumors about what had happened, the U.S. Government announced that an Army munitions dump had exploded, publicly revealing the truth only after it dropped a uranium-fueled gun-type nuclear bomb on Hiroshima on August 6 1945, ultimately killing over 200,000 people and wounding 79,000. Four days later, the United States dropped a nuclear device similar to *Trinity* on the Japanese city of Nagasaki, eventually killing 60–90,000 people and wounding 60,000; the design was mass-produced as the Mark III bomb, and was stockpiled from 1947 to 1950. *Trinity* left a crater in the desert 9.5' deep by 1100' wide; people as far away as Santa Fe and El Paso saw the detonation flash, and the radioactive debris cloud rose to 35,000'. Image by Berlyn Brixner, Los Alamos Scientific Laboratory photographer, from an ultra-high-speed *Fastax* motion picture camera negative.

007. **APPLE-1**, Operation TEAPOT (see also #031). 4:55am March 29 1955, Nevada Test Site, tower detonation at 500', yield 14 kilotons. Silhouetted against light which literally illuminated their insides, soldiers try to shield themselves from *Apple-1*'s expanding fireball. Closer in, 600 troops observed the blast in trenches 1.98 miles from ground zero. Radiation at the blast point measured a potentially-lethal 500 roentgens/hour. The cluster of smoke trails visible at right are from rockets launched just before detonation to help measure the explosion's invisible air shock wave. *Apple-1* tested the primary and secondary stages of a thermonuclear bomb mockup that was predicted to yield 40 kilotons; detonation "fizzled" when the fusion secondary stage failed to ignite. Image by Sergeant James R. Covington, U.S. Army Photographic Signal Corps.

008. **STOKES**, Operation PLUMBBOB (see also #s 012, 013, 045). 5:25am August 7 1957, Nevada Test Site, balloon detonation at 1500', yield 19 kilotons. Averting their eyes at the moment of detonation while a few dark-goggled troop monitors stare directly on into the blast, members of a group of 499 U.S. Army soldiers are "conditioned" for the more powerful – and thermonuclear – *Smoky* shot to occur later in the Operation (see #s 023, 024). At this point, *Stokes*' fireball is 700 feet wide and its brightness is more than 50 times that of the sun; despite their shut and shielded eyes, many troops saw the bones of their arms and hands. The test device, of about the same yield as the 7300-pound nuclear core dropped on Nagasaki in 1945, weighed a mere 448 pounds. Eleven anti-nuclear testing pacifists were discovered inside the periphery of the Nevada Test Site the previous day and arrested. *Stokes* was a test of the W-30 air-defense and tactical atomic warhead, stockpiled from 1959 to 1979, with a variable yield of 140 tons to 19 kilotons. Image by Private Paul W. Hocking, U.S. Army Photographic Signal Corps.

009. **WHEELER**, Operation PLUMBBOB. 5:45am September 6 1957, Nevada Test Site, balloon detonation at 500', yield 197 tons. Igniting the tether cables that steadied what used to be the balloon slightly above it, *Wheeler*'s fireball expands outwards. This tiny, extremely light 158-pound nuclear device was a prototype for what probably went on to become the W-54 air-to-air defense and tactical missile warhead, stockpiled from 1961 to 1972, with a variable yield of 10 tons to 6 kilotons. The W-54 was proof-tested with the portable, one-man operated "Davy Crockett" launcher in *Little Feller I* (see #046). Despite being an uncharacteristically small device from Edward Teller's University of California Radiation Laboratory, known for its massive thermonuclear designs, *Wheeler*'s radioactive debris cloud rose to 17,000'. Image by U.S. Air Force 1352nd Photographic Group, Lookout Mountain Station.

010. **FRANKLIN PRIME**, Operation PLUMBBOB. 5:40am August 30 1957, Nevada Test Site, balloon detonation at 750', yield 4.7 kilotons. Photographed at the moment where its fireball has progressed outwards enough to begin rising vertically, *Franklin Prime* begins to suck up alluvial soil from the desert below to form the classic nuclear "mushroom" cloud. Three months earlier, the first Franklin test "fizzled," yielding only 7% of its predicted yield. Like *Stokes*, *Franklin Prime* was a test of the W-30 air-defense and tactical atomic warhead, stockpiled from 1959 to 1979, with a variable yield of 140 tons to 19 kilotons. Its radioactive debris cloud rose to 27,800'. Image by U.S. Air Force 1352nd Photographic Group, Lookout Mountain Station.

011. **LAPLACE**, Operation PLUMBBOB. 6:00am September 8 1957, Nevada Test Site, balloon detonation at 750', yield 1 kiloton. Having expanded enough to create strong areas of low atmospheric pressure, *Laplace*'s fireball grows a "stem" to its burgeoning "mushroom" cloud as it sucks desert soil upwards into its core. *Laplace* was a test of a tactical nuclear weapon used for low airbursts, weighing 503 pounds, and was possibly a prototype neutron bomb. A neutron bomb is one designed to minimize blast and heat effects, while maximizing deadly radiation. The radioactive debris cloud rose to 15,800'. Image by U.S. Air Force 1352nd Photographic Group, Lookout Mountain Station.

012. **STOKES**, Operation PLUMBBOB (see also #s 008, 013, 045). 5:25am August 7 1957, Nevada Test Site, balloon detonation at 1500', yield 19 kilotons. After its shock wave hits the ground and agitates alluvial soil in a broad circle, *Stokes* begins to suck it up in a central stem, created by atmospheric low-pressure from the blast. Its radioactive debris cloud would eventually rise to a height of 37,000'. *Stokes* was a test of the W-30 air-defense and tactical atomic warhead, stockpiled from 1959 to 1979, with a variable yield of 140 tons to 19 kilotons. Image by U.S. Air Force 1352nd Photographic Group, Lookout Mountain Station.

013. **STOKES**, Operation PLUMBBOB see also #s 008, 012, 045). 5:25am August 7 1957, Nevada Test Site, balloon detonation at 1500', yield 19 kilotons. Red aerial view of the *Stokes* fireball at the same moment as the surface view described above, photographed with special film. Alluvial soil drainage, service roads, and nearby mountains of the Nevada Test Site are clearly visible. *Stokes* was a test of the W-30 air-defense and tactical atomic warhead, stockpiled from 1959 to 1979, with a variable yield of 140 tons to 19 kilotons. Image by U.S. Air Force 1352nd Photographic Group, Lookout Mountain Station.

014. **HOW**, Operation TUMBLER-SNAPPER (see also #005). 3:55am June 5 1952, Nevada Test Site, tower detonation at 300', yield 14 kilotons. In a red aerial view photographed with special film, *How*'s fireball has yet to rise and break away from the ground at this stage in its progression. Radiation levels at ground zero reached intense levels of 1500 roentgens/hour, and the fission debris cloud rose to 37,000', eventually being tracked all the way to Germany. *How* would become the Mark-12 bomb, a jet fighter-carried tactical

weapon of 12 to 14 kilotons yield that was stockpiled from 1954 to 1962. Image by U.S. Air Force 1352nd Photographic Group, Lookout Mountain Station.

015. **SUGAR**, Operation JANGLE (see also #041). 9:00am November 19 1951, Nevada Test Site, surface detonation at 3.5', yield 1.2 kilotons. Surrounded by glowing ionized air, Sugar's fireball rises upwards, taking much Nevada desert with it. A weapons-effects test investigating the nature of a nuclear surface burst, this relatively small-yield detonation vaporized 50,000 cubic feet of soil, eventually lofting it to a height of 11,000'. The crater measured 90' wide and 21' deep. Sugar created especially intense radioactivity, with the lip of the crater measuring a potentially deadly 7500 roentgens/hour; four minutes exposure to such energy is immediately lethal. Troops observed the blast from 5.5 miles away, and maneuvers were conducted a substantial distance from ground zero due to the contamination. One of the first detonations at the newly created Nevada Test Site, Sugar offered an early lesson to the Atomic Energy Commission: the greater the distance between the blast and the ground, the less surface radioactivity and radioactive fallout in the debris clouds. Ever-higher towers, and finally balloons, were used in successive Nevada operations to try to calm an American public increasingly aware of the profound dangers from fallout, while behind closed doors even some of the A.E.C.'s own commissioners argued for moving all testing to the Pacific. Image by U.S. Air Force 1352nd Photographic Group, Lookout Mountain Station.

016. **ZUCCHINI**, Operation TEAPOT (see also #037). 5:00am May 15 1955, Nevada Test Site, tower detonation at 500', yield 28 kilotons. Vaporizing its tower, Zucchini's fireball moves outwards and upwards; it was a test of the fission primary stage of a two-stage thermonuclear bomb mockup. 500 roentgens/hour of radiation was measured at ground zero after the blast, and the radioactive debris cloud rose to 40,000'. Image by U.S. Air Force 1352nd Photographic Group, Lookout Mountain Station.

017. **FOX**, Operation TUMBLER-SNAPPER. 4:00am May 25 1952, Nevada Test Site, tower detonation at 300', yield 11 kilotons. Fox's fireball, here appearing quite vertical, engulfs its tower. 950 troops from the Army's 701st Armored Infantry Battalion observed the detonation 3.97 miles from the blast and then maneuvered towards ground zero, which measured a potentially-lethal 2000 roentgens/hour at a distance of 400 yards. Shortly before the Operation Tumbler-Snapper tests the Atomic Energy Commission relented to the Department of Defense's demand to move troops closer to the blast, pending D.O.D. absolution of the A.E.C. of any responsibility for adverse health effects. A.E.C. doctors were furious that their own 7-mile-distance safety guidelines for A.E.C. staff were being sidestepped by the military. From this point forward, "troop-testing" tactical atomic weapons on the battlefield began in earnest. Using a Mark-5 bomb assembly, Fox tested new neutron initiation designs that enhanced fission efficiency. The Mark-5 was stockpiled from 1952 to 1963, and yielded 11 to 47 kilotons. The radioactive debris cloud rose to 41,000'. Image by U.S. Air Force 1352nd Photographic Group, Lookout Mountain Station.

018. **HOOD**, Operation PLUMBBOB (see also #s 028, 048). 4:40am July 5 1957, Nevada Test Site, balloon detonation at 1500', yield 74 kilotons. Aerial photograph showing Hood's massive and enduring fireball as it churns upwards. Hood was the largest atmospheric nuclear test ever conducted on the continental United States, and the first true two-stage thermonuclear device detonated in Nevada. The flash was seen in Canada, also a first. 2500 Marines participated in troop maneuvers, with a select number stationed in trenches 2 miles away from ground zero. After detonation, 900 soldiers advanced to an objective near ground zero while 124 aircraft and troop helicopters coordinated a ground "invasion" of the blast site itself, which measured 100 roentgens/hour of radiation. Hood broke a longstanding "gentleman's agreement" between the Federal Government and the Department of Defense that the nuclear weapons labs would not detonate a hydrogen bomb at the Nevada Test Site; the government continued to state at the time that no thermonuclear weapons were being detonated there and maintained the lie until the dissolution of the A.E.C. in 1974. Like Operation Plumbbob's other infamous thermonuclear shots Smoky (see #s 023, 024) and Charleston (#001), Hood was created by Edward Teller's University of California Radiation Laboratory. Billed by Teller to President Eisenhower as a "clean" – i.e. low fallout – explosion, Hood was in fact one of the dirtiest U.S. continental atmospheric tests ever detonated. Total weight of the device was 393 pounds; it was a prototype for eventual use on a missile warhead. Its radioactive debris cloud rose to a height of 43,770'. Image by U.S. Air Force 1352nd Photographic Group, Lookout Mountain Station.

019. **SIMON**, Operation UPSHOT-KNOTHOLE. 4:30am April 25 1953, Nevada Test Site, tower detonation at 300', yield 43 kilotons. Seven volunteer soldiers in a trench shield themselves from Simon's detonation, while the photographer captures the moment by fission light, bright enough to be seen from the moon. In a moment the ground and air shockwaves will toss them like dolls, then fill their mouths with radioactive dust and also make it temporarily impossible to see. Simon was the largest U.S. continental nuclear test to date. 3000 troops witnessed the detonation; for the first time a group of them would "attack" ground zero, where 300 roentgens/hour of radiation were recorded. Simon's radioactive debris cloud rose to a height of 44,000', grew to a width of 80 miles, and then scattered deadly fallout throughout southwest Utah, particularly the town of St. George, 100 miles to the east of the test site. The Atomic Energy Commission banned airplane flights over the area, and despite closing all roads in the region, 40 vehicles were contaminated; highly radioactive rain fell in Albany, New York the following day. Simon tested the primary stage of a thermonuclear bomb mockup, leading to the Mark-17 and Mark-24 bombs which were stockpiled from 1954 to 1957. With a yield of 10 to 15 megatons, they were some of the largest and deadliest weapons ever deployed by the United States. Image by U.S. Army Photographic Signal Corps.

020. **FIZEAU**, Operation PLUMBBOB. 9:45am September 14 1957, Nevada Test Site, tower detonation at 500', yield 11 kilotons. Photographed with a telephoto lens, Fizeau's fireball dwarfs the surrounding Nevada landscape. Most nuclear tests were detonated shortly before dawn for security reasons as well as better photographic analysis, but Fizeau's 9:45am detonation offers a rare close-up view of a fireball set in fully discernable surroundings. Fizeau was probably a prototype test of the W-34 warhead, stockpiled from 1958 to 1977 and yielding 11 kilotons. The W-34 was used in anti-submarine warfare, and Fizeau's nuclear device weighed only 131 pounds; its radioactive debris cloud rose to 40,000'. Image by U.S. Air Force 1352nd Photographic Group, Lookout Mountain Station.

021. **CLIMAX**, Operation UPSHOT-KNOTHOLE. 3:15am June 4 1953, Nevada Test Site, airdrop detonation at 1334', yield 61 kilotons. Low-level aerial photograph of Climax shortly after detonation, showing the rising stem debris cloud just about to meet the fireball. The cluster of smoke trails at left are from rockets fired just before detonation to help photographically measure the explosion's invisible air shock wave. Climax was the largest U.S. continental test to date, setting the desert on fire five miles away from ground zero and creating a radioactive cloud that rose to 42,700'. The fission detonation was as efficient as it was large: the initial flash of light, normally lasting only about a second, here lasted for five; the fireball raged for a minute, six times longer than usual, and the cloud remained incandescent for two minutes, rather than the normal one. Climax proof-tested the Mark-7 bomb, a small and light tactical nuclear weapon ranging in yield from 8 to 61 kilotons that was stockpiled from 1952 to 1967. The Mark-7 core would later be used as a primary stage in several high-yield two-stage thermonuclear devices in the Operation Castle test series of 1954. Image by U.S. Air Force 1352nd Photographic Group, Lookout Mountain Station.

022. **HORNET**, Operation TEAPOT (see also #004). 5:20am March 12 1955, Nevada Test Site, tower detonation at 300', yield 4 kilotons. Seen from a distance of 8 miles or more, Hornet's cooling fireball and debris cloud still continues to radiate much visible energy in the form of ionized glowing air; in this long photographic exposure it appears as an undifferentiated white mass. Hornet was a boosted-prototype test of what would become the W-30 warhead, an air-defense weapon that was stockpiled from 1959 to 1979 with a yield of 140 tons to 19 kilotons (see Moth, #002, for an un-boosted test). Total weight of the suitcase-sized weapon was 500 pounds. Mice were deployed rather than soldiers during Hornet: it was thought that creation of a smog from smoke pots near ground zero might mitigate the heat from the atomic blast. It did not, and actually increased radioactivity, which measured an intensely hot 2500 roentgens/hour at ground zero. Hornet's fallout cloud rose to 37,000'. Image by Sergeant W.F. Parkinson, U.S. Army Photographic Signal Corps.

023/024. **SMOKY**, Operation PLUMBBOB. 5:30am August 31 1957, Nevada Test Site, tower detonation at 700', yield 44 kilotons. At left, nine soldiers shield themselves from the dangerously strong light of the detonation several miles away; at right they have turned to watch a few moments later, some plugging their ears against the noise, as Smoky's cooling fireball churns upwards surrounded by a halo of ionized, glowing air. Smoky's radioactive debris cloud would eventually rise to 33,500'. Participating in "Task Force Big Bang," troops from the Army's 1st Battle Group and a contingent of paratroopers from the 82nd Airborne Division observed the blast, some deployed in trenches as close as 1.7 miles from ground zero. After the blast, combat groups advanced on the blast point, and one group stopped only 300 feet from the bomb tower wreckage, though radiation at ground zero measured a very dangerous 300 roentgens/hour. A two-stage explosion to test the Mark-41 three-stage nuclear bomb primary and secondary, Smoky was the second instance of thermonuclear detonation on the continental United States after Hood. Jointly produced by the Los Alamos and University of California labs, the Mark-41 was stockpiled from 1960 to 1976, and at 25 megatons yield was the most destructive weapon the United States ever produced, about 65% larger than its largest test, 15-megaton Bravo (see #'s 093, 099). A single 25-megaton bomb carries the equivalent explosive power of 1,666 Hiroshima bombs. Images by Don T. Taniguchi, U.S. Army Photographic Signal Corps.

025. **DIABLO**, Operation PLUMBBOB. 4:30am July 15 1957, Nevada Test Site, tower detonation at 500', yield 17 kilotons. Towering over the desert floor, Diablo's debris cloud glows with ionized air, said by observers to be purplish-blue in color. With 2500 Marines deployed in trenches 1.98 miles from ground zero, the first attempt to detonate Diablo on June 28 was a failure – the switch was thrown and nothing happened. It was later discovered that an important electrical cable in the tower had been damaged; after repair, the second attempt was successful. Ground zero measured 200 roentgens/hour of radiation, and the debris cloud rose to 27,531'. Diablo was a test of the primary stage of a two-stage thermonuclear device. Image by U.S. Air Force 1352nd Photographic Group, Lookout Mountain Station.

026. **WHITNEY**, Operation PLUMBBOB. 5:30am September 23 1957, Nevada Test Site, tower detonation at 500', yield 19 kilotons. Seen from the ground, Whitney's debris cloud glows with ionized air. Whitney was a test of a primary stage variant of the two-stage W-27 warhead, stockpiled from 1958 to 1965, and yielding 2 megatons. Radiation at ground zero measured 200 roentgens/hour, and Whitney's debris cloud rose to 25,500'. Image by U.S. Air Force 1352nd Photographic Group, Lookout Mountain Station.

027. **SHASTA**, Operation PLUMBBOB. 5:00am August 18 1957, Nevada Test Site, tower detonation at 500', yield 17 kilotons. Shasta's ionization corona, said to be purplish-blue, glows as its fireball cools. Shasta was a test of the primary stage of a two-stage thermonuclear device, much like Diablo, and exhibited similar characteristics. Radiation at ground zero measured 500 roentgens/hour, and the debris cloud rose to 28,000'. Image by U.S. Air Force 1352nd Photographic Group, Lookout Mountain Station.

028. **HOOD**, Operation PLUMBBOB (see also #s 018, 048). 4:40am July 5 1957, Nevada Test Site, balloon detonation at 1500', yield 74 kilotons. Its fireball having cooled and now surrounded by a corona of ionized air, the Hood debris cloud moves upwards on its way to a final height of 43,770'. Sparse desert plant life several miles away from ground zero burns, set alight by the heat of the blast. Hood was the largest atmospheric nuclear test ever conducted on the continental United States, and the first true two-stage thermonuclear device detonated in Nevada. Total weight of the device was 393 pounds; it was a prototype for eventual use on a missile warhead. Image by SP3 William R. Lucas, U.S. Army Photographic Signal Corps.

029/030. **TURK**, Operation TEAPOT. 5:20am March 7 1955, Nevada Test Site, tower detonation at 500', yield 43 kilotons. In the image at left, two soldiers huddle in a trench less than two miles from ground zero as Turk detonates, while the photographer exposes the negative by fission light. In the image at right, made from a hill just above the media bleachers of "News Nob," Turk's fireball expands outwards 13 miles away with such brightness that it solarizes the photographic negative. Visible in both images are the cluster of smoke trails from rockets set off just before detonation to help measure the explosion's invisible air shock wave. The two soldiers pictured were joined by 600 other troops in trenches less than 2 miles from the blast site; after Turk's detonation a potentially deadly 1000 roentgens/hour was measured at ground zero. The flash was seen a thousand miles away in Bellingham, Washington, and the radioactive fallout cloud rose to 44,700'. Turk was a test of the primary fission stage of what would become the W-27 thermonuclear ballistic missile warhead, stockpiled from 1958 to 1965 and yielding 2 megatons. Left: U.S. Army Signal Corps photograph by Sergeant W.F. Parkinson. Right: U.S. Army Signal Corps photograph by Sergeant R. Cogswell.

031. **APPLE-1**, Operation TEAPOT (see also #007). 4:55am March 29 1955, Nevada Test Site, tower detonation at 500', yield 14 kilotons. This long-duration photographic exposure shows a truck backing out of the image frame while Apple-1's debris cloud moves upward in the distance thirteen miles away, its fireball having cooled to the point where a purple-blue ionization glow can be seen. Apple-1 was a test of the primary and secondary stages of a thermonuclear bomb mockup; it "fizzled" when the primary failed to ignite the secondary, leading to a 35% decrease in yield. The radioactive debris cloud rose to 32,000'. Image by Sergeant W.F. Parkinson, U.S. Army Photographic Signal Corps.

032. **PRISCILLA**, Operation PLUMBBOB (see also #s 033, 034, 035). 6:30am June 24 1957, Nevada Test Site, balloon detonation at 700', yield 37 kilotons. Creating a second dawn, the *Priscilla* fireball rises upwards in a rare, double-tiered cloud surrounded by a halo of fire. The radioactive debris would eventually rise to a height of 43,000'. Troops were stationed in trenches 2 miles from ground zero, and were mistakenly allowed to maneuver within 900' of the blast site, which measured a potentially-deadly 500 roentgens/hour. *Priscilla* was a weapons-effects test to investigate various bomb shelter designs; it used the primary fission stage of the two-stage Mark-39 thermonuclear bomb, stockpiled from 1957 to 1966 and yielding 3 to 4 megatons. Image by U.S. Air Force 1352nd Photographic Group, Lookout Mountain Station.

033/034. **PRISCILLA**, Operation PLUMBBOB (see also #s 032, 035). 6:30am June 24 1957, Nevada Test Site, balloon detonation at 700', yield 37 kilotons. In a photographic diptych showing the moment of detonation followed by *Priscilla*'s distinctive double-tiered cloud, members of the Lookout Mountain Air Force Station document the test with still and motion picture cameras. Note the differences in shadows and atmosphere between the two photographs, as exposure demands shift from detonation to its aftermath. From 1947 to 1969, the Hollywood-based photographers and cinematographers of Lookout Mountain were charged with visually recording all aspects of U.S. nuclear tests at the Nevada Test Site as well as offshore tests in the Pacific Proving Grounds. Images by U.S. Air Force 1352nd Photographic Group, Lookout Mountain Station.

035. **PRISCILLA**, Operation PLUMBBOB (see also #s 032, 032, 034). 6:30am June 24 1957, Nevada Test Site, balloon detonation at 700', yield 37 kilotons. In a blue aerial image made with special film, *Priscilla*'s unusual double-tiered cloud and fire-halo rise upwards amongst the basins and ranges of Nevada's geology, visible to the horizon. Image by U.S. Air Force 1352nd Photographic Group, Lookout Mountain Station.

036. **GRABLE**, Operation UPSHOT-KNOTHOLE. 7:30am May 25 1953, Nevada Test Site, airburst detonation at 524', yield 15 kilotons. In the only example other than *Priscilla* of a double-tiered cloud ringed by a halo of fire, *Grable*'s fireball rises upwards, here photographed in a yellow view with special film. Visible to the left are a cluster of smoke trails from rockets launched just before detonation to help photographically measure the explosion's invisible air shock wave. *Grable* was a proof-test of the new artillery-fired Mark-9 nuclear weapon, stockpiled from 1952 to 1957. Fired at a target 6 miles away from an 85-ton, 280mm cannon, *Grable* so inspired politicians that members of the U.S. Congress clamored for the use of the Mark-9 during the Korean War. For the blast, troops were stationed in trenches 2.84 miles from ground zero; later, 75 military physicians would be located 1.42 miles from the blast point to observe 2600 troops maneuver under the radioactive debris cloud, one that would eventually rise to 35,000'. Image by U.S. Air Force 1352nd Photographic Group, Lookout Mountain Station.

037. **ZUCCHINI**, Operation TEAPOT (see also #016). 5am May 15 1955, Nevada Test Site, tower detonation at 500', yield 28 kilotons. Members of the Canadian and British military observe detonation from bleachers set up for visitors and the media as *Zucchini* explodes 13 miles away. *Zucchini* was a test of the fission primary stage in a two-stage thermonuclear bomb mockup. 500 roentgens/hour of radiation was measured at ground zero after the blast, and the radioactive debris cloud rose to 40,000'. Image by U.S. Air Force 1352nd Photographic Group, Lookout Mountain Station.

038. **MET**, Operation TEAPOT (see also #s 043, 044). 11:15am May 15 1955, Nevada Test Site, tower detonation at 400', yield 22 kilotons. Aerial photograph of *Met* made from an altitude of approximately 15,000'; its radioactive debris cloud would eventually rise to a height of 40,300'. *Met* was a "Military Effects Test" that investigated, among other things, radiation effects on the winter and summer uniforms of Soviet and Chinese troops. Image by U.S. Air Force 1352nd Photographic Group, Lookout Mountain Station.

039. **DOG**, Operation BUSTER (see also #040). 7:30am November 1 1951, Nevada Test Site, airdrop detonation at 1417', yield 21 kilotons. Seen left to right, U.S. Army 11th Airborne Division soldiers Schmidt, Wilson, Zerfas, Roth, Moore and Schleuter observe the *Dog* fireball after detonation. *Dog* was the first "troop-test" deployment by the Department of Defense, which placed soldiers 6.8 miles away from the blast point. The Army wanted them much closer to create "familiarity" with the effects of nuclear weapons, but the Atomic Energy Commission refused, citing the seven-mile-distance safety guidelines it required for its own personnel. The A.E.C. would shortly relinquish all control to the military (see *Fox*, #017), however, and later tests would place troops less than 2 miles from ground zero at detonation and allow maneuvers to ground zero shortly thereafter. Image by Corporal Alexander McCaughey, U.S. Army Photographic Signal Corps.

040. **DOG**, Operation BUSTER (see also #039). 7:30am November 1, 1951, Nevada Test Site, airdrop detonation at 1417', yield 21 kilotons. U.S. Army 11th Airborne Division soldiers watch the *Dog* debris cloud rise 6.8 miles away. 2796 troops observed the detonation; 883 troops then "attacked" an objective 500 yards from ground zero in the world's first "atomic warfare maneuver"; sixty of these troops went even closer. Eight minutes after detonation the radioactive debris cloud would reach 46,000'. *Dog* used the Mark-4 bomb, stockpiled from 1949 to 1953, with a variable yield of 1 to 31 kilotons. Image by Corporal Alexander McCaughey, U.S. Army Photographic Signal Corps.

041. **SUGAR**, Operation JANGLE (see also #015). 9:00am November 19 1951, Nevada Test Site, surface detonation at 3.5', yield 1.2 kilotons. Red aerial photograph of the *Sugar* detonation, shot with special film from an altitude of approximately 10,000'. The cluster of smoke trails visible to the left of the fireball are from rockets launched just before detonation to help photographically measure the explosion's invisible air shock wave. *Sugar* was a weapons-effects test that investigated the nature of a surface burst. Image by U.S. Air Force 1352nd Photographic Group, Lookout Mountain Station.

042. **EASY**, Operation BUSTER. 8:30am November 5 1951, Nevada Test Site, airdrop detonation at 1314', yield 31 kilotons. Orange aerial photograph of the *Easy* detonation, shot with an special film from an altitude of approximately 5000'. *Easy* was the largest continental test to date; the shockwave effect on the alluvial desert soil is clearly visible. Its radioactive debris cloud would climb to an eventual height of 50,000'. *Easy* tested a prototype of the Mark-7 bomb, stockpiled from 1952 to 1967 and yielding 8 to 61 kilotons. Image by U.S. Air Force 1352nd Photographic Group, Lookout Mountain Station.

043/044. **MET**, Operation TEAPOT (see also #038). 11:15am May 15 1955, Nevada Test Site, tower detonation at 400', yield 22 kilotons. At left, U.S. Army soldiers turn away and shield themselves from the *Met* detonation blast 6 miles away; at right they watch its rising debris cloud. A total of 260 troops observed the test, and the cloud would eventually rise to 40,300'. *Met* was a "Military Effects Test" that investigated, among other things, radiation effects on the winter and summer uniforms of Soviet and Chinese troops. It used a Mark-7 bomb, stockpiled from 1952 to 1967, with a variable yield of 8 to 61 kilotons. Images by Sergeant Anthony J. Ouellette, U.S. Army Photographic Signal Corps.

045. **STOKES**, Operation PLUMBBOB (see also #s 008, 012, 013). 5:25am August 7 1957, Nevada Test Site, balloon detonation at 1500', yield 19 kilotons. In an image showing the aftermath of a strange experiment, an unmanned Navy ZSG-3 airship is released into the air just after detonation to test its response to the force of an atomic air shock wave; predictably enough, its envelope ruptures and it gently lodges on the desert floor. The debris cloud rises in the distance. *Stokes* was a test of the W-30 air-defense and tactical atomic warhead, stockpiled from 1959 to 1979, with a variable yield of 140 tons to 19 kilotons. Image by U.S. Air Force 1352nd Photographic Group, Lookout Mountain Station.

046. **LITTLE FELLER I**, Operation SUNBEAM. 9:00am July 17 1962, Nevada Test Site, rocket detonation at 40', yield 18 tons. In an aerial photograph looking north made from about 3000', *Little Feller I*'s debris cloud rises about 40 seconds after detonation. *Little Feller I* was the last atmospheric nuclear test at the Nevada Test Site, and used the tiny W-54 air defense and tactical warhead to proof-test the one-man-operated "Davy Crockett" nuclear rocket launcher. The W-54 was stockpiled from 1961 to 1972, with a variable yield of 10 tons to 6 kilotons, and weighed only 50 pounds. Image by U.S. Air Force 1352nd Photographic Group, Lookout Mountain Station.

047. **WILSON**, Operation PLUMBBOB. 4:45am June 18 1957, Nevada Test Site, balloon detonation at 500', yield 10 kilotons. Seen in a long-exposure photograph, a portion of *Wilson*'s detonation cloud, five miles distant, drifts in the early morning wind. About 1000 troops observed the blast, and the cloud would eventually rise to a height of 35,000'. *Wilson* tested a prototype of the single-stage, 150-pound W-45 warhead, stockpiled from 1961 to 1989, with a yield of 500 tons to 15 kilotons. Image by U.S. Air Force 1352nd Photographic Group, Lookout Mountain Station.

048. **HOOD**, Operation PLUMBBOB (see also #s 018, 028). 4:40am July 5 1957, Nevada Test Site, balloon detonation at 1500', yield 74 kilotons. Within an hour of detonation, U.S. Marine helicopters fly north and east around *Hood*'s dispersing debris cloud, helping to coordinate a ground-troop "invasion" of ground zero. *Hood* was the largest atmospheric nuclear test conducted on the continental United States, and the first true two-stage thermonuclear device exploded there. Total weight of the device was 393 pounds; it was a prototype for eventual use on a missile warhead. 2500 Marines participated in troop maneuvers; after detonation, 900 soldiers advanced to an objective near ground zero, which measured 100 roentgens/hour of radiation, while 124 aircraft flew above. The radioactive debris cloud rose to a height of 43,770'. Image by SP3 William R. Lucas, U.S. Army Photographic Signal Corps.

049. **JOHN**, Operation PLUMBBOB. 7:00am July 19 1957 Nevada Test Site, rocket detonation at 20,000', yield 1.7 kilotons. In this north-looking image, *John* explodes high in the early morning sky; shadows from the natural sun can be seen amongst the sagebrush. 5 volunteers stood at ground zero 4 miles beneath the blast; *John*'s debris cloud rose to 40,000 feet. *John* proof-tested the W-25 warhead on the "Genie" rocket, demonstrating the capability of an air-to-air nuclear missile designed to destroy incoming Soviet strategic bombers. The 218-pound W-25 was stockpiled from 1956 to 1984 and yielded 1 to 2 kilotons. Image by M/SP Don T. Taniguchi, U.S. Army Photographic Signal Corps.

050. **X-RAY**, Operation SANDSTONE (see also #051). 6:17am April 15 1948, Engebi Island, Enewetak Atoll, tower detonation at 200', yield 37 kilotons. In an aerial view looking down over ground zero, *X-Ray* explodes in the Pacific Ocean amidst scattered early morning clouds, with Engebi Island and the curving reef edge of Enewetak Atoll visible. Operation *Sandstone* was approved by U.S. President Harry Truman in June of 1947 to develop an entirely new generation of atomic weapons from those initially generated by the Manhattan Project and used on Japan at the end of World War II. Because of its isolation, Enewetak Atoll in the Marshall Islands was selected over Bikini Atoll as a new location for the tests in September 1947. In December its 142 natives were relocated to Ujelang Atoll, 143 miles distant. A total of 43 nuclear weapons tests were conducted by the United States at Enewetak over the next decade, most of them thermonuclear and of massive destructive capacity. Image by U.S. Air Force 1352nd Photographic Group, Lookout Mountain Station.

051. **X-RAY**, Operation SANDSTONE (see also #050). 6:17am April 15 1948, Engebi Island, Enewetak Atoll, tower detonation at 200', yield 37 kilotons. Obliterating Engebi Island, *X-Ray*'s fireball roars upwards in this aerial view seen from about 2000' altitude; the curving edge of the shallow atoll lagoon and the deeper ocean beyond is clearly visible. *X-Ray*, and the two other Sandstone tests, were weapons-development tests that explored new composite methods of constructing the core of a nuclear weapon, as well as the principle of core "levitation." Application of these innovations effected efficiency gains that led to an immediate 75% increase in the yield of the total U.S. nuclear stockpile. *X-Ray* was a prototype of the Mark-4 bomb design, which was the first mass-produced nuclear weapon. It was stockpiled from 1949 to 1953, with a variable yield of 1 to 31 kilotons. Image by U.S. Air Force 1352nd Photographic Group, Lookout Mountain Station.

052. **YOKE**, Operation SANDSTONE. 6:09am May 1 1948, Aomon Island, Enewetak Atoll, tower detonation at 200', yield 49 kilotons. Photographed from a neighboring island, *Yoke*'s fireball rises amidst cloud cover in the humid Pacific morning. At 49 kilotons *Yoke* was the largest-yielding nuclear detonation to date, and further tested composite-core and "levitation" principles. Like *X-Ray*, it was a prototype of the Mark-4 bomb design, which was the first mass-produced nuclear weapon. It was stockpiled from 1949 to 1953, with a variable yield of 1 to 31 kilotons. Image by U.S. Air Force 1352nd Photographic Group, Lookout Mountain Station.

053. **GEORGE**, Operation GREENHOUSE. 9:30am May 9 1951, Eberiru Island, Enewetak Atoll, tower detonation at 200', yield 225 kilotons. In the world's first thermonuclear explosion, and the largest nuclear detonation to date, the *George* fireball grows in this red aerial view made with special film. Shrouding the fireball is the Wilson cloud effect caused by a low-pressure zone just behind the blast's rapidly advancing shock wave that makes water vapor temporarily condense from the tropical air. The shock wave itself appears clearly as a white disk on the water, known as the "crack", surrounding the Wilson cloud. Unlike detonations in the dry Nevada desert, nuclear tests in the humid Pacific Proving Grounds tended to create their own weather systems. A physics experiment, *George* was the first test of deuterium-tritium fusion ignition as well as device implosion by radiation rather than high explosives. It measured for its designer, Edward Teller, some of the reaction processes that would be critical to the success of the massive thermonuclear detonation

Mike – 46 times larger – that would occur a year later. *George* created a crater 30' deep and 500' wide; its radioactive debris cloud rose to a height of 70,000'. Image by U.S. Air Force 1352nd Photographic Group, Lookout Mountain Station.

054. **ERIE**, Operation REDWING. 6:15am May 31 1956, Runit Island, Enewetak Atoll, tower detonation at 300', yield 14.9 kilotons. Turning their backs and covering their eyes, personnel shield themselves from *Erie*'s detonation flash. *Erie* tested a prototype of the primary stage of the Mark-28 thermonuclear bomb; stockpiled from 1958 to 1991 with a variable yield of 70 kilotons to 1.45 megatons. The radioactive debris cloud rose to a height of 32,000'. Image by U.S. Air Force 1352nd Photographic Group, Lookout Mountain Station.

055. **ABLE**, Operation CROSSROADS (see also #056). 9:00am July 1 1946, Bikini Atoll lagoon, airdrop detonation at 520', yield 21 kilotons. In the first nuclear detonation after World War Two, *Able*'s detonation flash sears the morning sky in this aerial view made at about 1000', probably by an unmanned remotely-controlled drone aircraft. Operation *Crossroads* was announced by U.S. President Harry Truman in December 1945 to determine the effects of existing atomic bombs on naval vessels, to train bombing crews in atomic warfare, and to investigate nuclear blast effects in general. Bikini Atoll in the Marshall Islands was selected as the location for the new tests in January of 1946; 162 Bikinians were relocated to Rongerik Atoll 128 miles to the East on March 7, thinking that the move was temporary and convinced by the United States that their evacuation would contribute to world peace. *Crossroads* personnel grew to 42,000, making it the largest peacetime military operation to date. A total of 23 nuclear weapons tests were conducted by the United States at Bikini over the next 12 years, most of them thermonuclear and of massive destructive capacity. Image by U.S. Army Photographic Signal Corps.

056. **ABLE**, Operation CROSSROADS (see also #055). 9:00am July 1 1946, Bikini Atoll lagoon, airdrop detonation at 520', yield 21 kilotons. Seen from ground level, *Able*'s debris cloud rises to an altitude of 26,400'. Comprised of radioactive fission products, water vapor, and smoke and soot, at its crest the cloud shows a cap, or scarf cloud, composed of ice crystals; eventually the cloud would reach 40,000'. Operation *Crossroads* assembled a fleet of more than 71 decommissioned WWII U.S., German and Japanese vessels as a nuclear "target armada" in Bikini Atoll lagoon. Missing its mark by 1800' due to bombardier error, *Able* sunk 5 ships, but much useful data was lost. Because it was a mid-air detonation, radiation contamination was relatively light, and nearly all the surviving target ships were boarded within a day. *Able* used a bomb of the same design and yield as that used to destroy the Japanese city of Nagasaki on August 9, 1945; the device was produced as the Mark 3 bomb and stockpiled from 1947 to 1950, yielding 21 kilotons. Image by U.S. Army Photographic Signal Corps.

057. **BAKER**, Operation CROSSROADS (see also #s 058, 059). 8:35 am July 25 1946, Bikini Atoll lagoon, underwater detonation at 90', yield 21 kilotons. Seen from the island of Eneu 10 seconds after detonation, *Baker* throws two million gallons of water over a mile high in a column 2000' wide, now just beginning to come back down and further devastate the decommissioned ghost fleet below. Dissipating remnants of the Wilson condensation cloud effect obscure the upper part of the image, but at left can be seen the stern of the 40,000-ton USS *Saratoga* rising 43' on the advancing wave crest of the "base surge," which reached 94' in height. *Baker* sank eight of the 71 target vessels, including the *Saratoga*, and immobilized an additional 8. It was the world's first underwater nuclear detonation, and because of its submerged nature and the resulting blast of water and coral, the explosion created intense radioactivity in the water, and surrounding atmosphere, creating unsafe personnel conditions for a week. Surface zero was measured at a potentially lethal 1000 roentgens/hour. The situation was complicated by the era's relative lack of knowledge about safe radiation exposure limit levels. Many of the remaining seaworthy ships in the target armada were so radioactive that they were eventually sunk offshore in deep water. Image by U.S. Army Photographic Signal Corps.

058. **BAKER**, Operation CROSSROADS (see also #s 057, 059). 8:35 am July 25 1946, Bikini Atoll lagoon, underwater detonation at 90', yield 21 kilotons. Seen in an aerial image made at 12,000', the *Baker* explosion is shrouded by its Wilson condensation cloud, caused by a low-pressure zone just behind the blast's rapidly advancing shock wave that makes water vapor temporarily condense from the humid air. The shock wave, known as the "crack", appears clearly as a white disk on the water surrounding the cloud, and is moving at this point at about 700 miles an hour. Each of the *Crossroads* tests was photographed simultaneously by 19 Army and 17 Navy aircraft, some of which were remote-controlled unmanned drones. Altogether, 1.5 million feet of motion picture film were exposed and more than a million still images were made, causing a worldwide shortage of film stock for months. Image by U.S. Army Photographic Signal Corps.

059. **BAKER**, Operation CROSSROADS (see also #s 057, 058). 8:35 am July 25 1946, Bikini Atoll lagoon, underwater detonation at 90', yield 21 kilotons. Photographed from a tower on Bikini island, the *Baker* detonation water column and the funnel-shaped "cauliflower head" above are caught at their apex, in what has become one of the world's most iconic images of nuclear destruction. At this point the Wilson condensation cloud has dissipated closer to the surface of the water, revealing the 2000'-wide water column and the decommissioned armada surrounding it, but still obscuring most of the expanding mushroom head. In an instant more than two million gallons of water will begin to fall downwards and create a "base surge" whose first wave will measure 94' high near surface zero. Four miles away, waves were 6 feet high. *Baker* used a bomb of the same design and yield as that used to destroy the Japanese city of Nagasaki on August 9 1945; the device was mass-produced as the Mark 3 bomb and stockpiled from 1947 to 1950, with a yield of 21 kilotons. Image by U.S. Army Photographic Signal Corps.

060. **SEMINOLE**, Operation REDWING. 12:55am June 7 1956, Bogon Island, Enewetak Atoll, surface detonation at 7', yield 13.7 kilotons. Its Wilson condensation cloud advancing just behind the expanding white disk of its air shock wave, *Seminole* creates a massive hole in Bogon Island in this aerial view made from about 12,000'. A test of the cratering effects of a high-yield device under controlled conditions, *Seminole* used a primary fission stage of a Mark-28 thermonuclear bomb submerged in a water tank to simulate an underground burst; the crater was 47' deep and 660' wide, and the radioactive debris cloud rose to a height of 16,000'. The Mark-28 was stockpiled from 1958 to 1991, with a variable yield of 70 kilotons to 1.45 megatons. Image by U.S. Air Force 1352nd Photographic Group, Lookout Mountain Station.

061. **HURON**, Operation REDWING. 6:12am July 22 1956, off Flora Island, Enewetak Atoll, barge detonation at 15', yield 270 kilotons. Seen from an altitude of about 8000', *Huron*'s glowing Wilson cloud and advancing air shockwave illuminate more natural Pacific weather. *Huron* was a test of a two-stage thermonuclear device, possibly a prototype of the W-50 warhead. The W-50 was stockpiled from 1963 to 1991, yielded 60 to 400 kilotons, and was used on the Pershing surface-to-surface tactical missile deployed in Europe. Image by U.S. Air Force 1352nd Photographic Group, Lookout Mountain Station.

062. **SEQUOIA**, Operation HARDTACK I. 6:30am July 2 1958, Enewetak Atoll, barge detonation at 6.5', yield 5.2 kilotons. Personnel watch from Parry Island as *Sequoia*'s glowing Wilson cloud lights the humid Pacific morning. *Sequoia* was probably a test of a prototype that eventually led to the tiny W-54 air defense and tactical nuclear warhead (see *Little Feller I*, #046). The W-54 was stockpiled from 1961 to 1972, with a variable yield of 10 tons to 6 kilotons, and weighed only 50 pounds. Image by U.S. Air Force 1352nd Photographic Group, Lookout Mountain Station.

063. **KING**, Operation IVY. 11:30am November 16 1952, Runit Island, Enewetak Atoll, airdrop at 1480', yield 500 kilotons. The largest and most efficient fission-only device ever detonated, *King*'s fireball roils its debris cloud long after most detonations have ceased to radiate visible light. The cloud eventually rose to 67,000'; to the right can be seen smoke trail lines from rockets launched just before detonation to help photographically measure the progression of the explosion's invisible air shock wave. Until *King* it was thought that the problem of "criticality" – wherein only so much fissionable material could be brought together in one weapon before it would self-detonate – would limit fission-only yield to a maximum of 250 kilotons. At the time, a large fission-only bomb was coveted by the U.S. military, due to the uncertainty of thermonuclear investigations; the spectacular thermonuclear success of *Mike*, *King*'s test companion in Operation *Ivy*, was far from guaranteed. *King* became the Mark-18 bomb, stockpiled from 1953 to 1956, with a yield of 500 to 550 kilotons. Image by U.S. Air Force 1352nd Photographic Group, Lookout Mountain Station.

064. **DOG**, Operation GREENHOUSE. 6:34am April 8 1951, Runit Island, Enewetak Atoll, tower detonation at 300', yield 81 kilotons. V.I.P.s wearing protective goggles watch *Dog* light the Pacific morning from Adirondack chairs in this image made on the "Officer's Beach Club Patio." The explosion lifted 250,000 tons of radioactive reef material to a height of 35,000'. *Dog* was a proof-test of the Mark-6 bomb, stockpiled from 1951 to 1962 and yielding 8 to 160 kilotons. Over a thousand were eventually produced. Image by U.S. Air Force 1352nd Photographic Group, Lookout Mountain Station.

065. **MIKE**, Operation IVY (see also #s 066, 067, 068, 069, 070). 7:15am November 1 1952, Eugelab Island, Enewetak Atoll, surface detonation at 10', yield 10.4 megatons. Captured by an automatic ultra-high speed camera, the world's first man-made sun instantly grows to a diameter of 3.5 miles and creates its own electrical storm. *Mike* was comprised of a huge, 82-ton refrigerator of super-cooled heavy hydrogen isotopes – liquid deuterium and tritium – which a fission atomic bomb trigger fused into helium, releasing the full thermonuclear power of the stars. Image from an Edgerton, Germeshausen, & Grier *Rapatronic* camera by U.S. Air Force 1352nd Photographic Group, Lookout Mountain Station.

066. **MIKE**, Operation IVY (see also #s 065, 067, 068, 069, 070). 7:15am November 1 1952, Eugelab Island, Enewetak Atoll, surface detonation at 10', yield 10.4 megatons. Seen in a telephoto aerial view made from about 30,000', the 3.5 mile-wide *Mike* fireball rushes upwards, partially obscured by ring-like condensation structures. *Mike* was the first test of a large-scale, "true" thermonuclear device, one based on the Teller-Ulam principles of staged radiation implosion. The explosion was the 4th largest nuclear test the United States ever detonated, equivalent to 10.4 million tons of TNT, greater in a single moment than all of the ordnance detonated in World Wars I and II combined. Image by U.S. Air Force 1352nd Photographic Group, Lookout Mountain Station.

067. **MIKE**, Operation IVY (see also #s 065, 066, 068, 069, 070). 7:15am November 1 1952, Eugelab Island, Enewetak Atoll, surface detonation at 10', yield 10.4 megatons. *Mike*'s fireball seen in a wider aerial view made from about 30,000', showing three ring cloud condensation structures. Image by U.S. Air Force 1352nd Photographic Group, Lookout Mountain Station.

068. **MIKE**, Operation IVY (see also #s 065, 066, 067, 069, 070). 7:15am November 1 1952, Eugelab Island, Enewetak Atoll, surface detonation at 10', yield 10.4 megatons. Aerial photograph made at about 30,000' of *Mike*'s debris cloud and stem, showing an ice cap and a dissipating ring cloud condensation structure. Within 1.5 minutes after detonation *Mike*'s cloud had climbed to 57,000'; half an hour later it measured 60 miles in diameter, with the stem joining the head at an altitude of 45,000'. The cloud would eventually reach an altitude of 142,000' and a maximum diameter of 100 miles. Eugelab Island was vaporized, leaving a crater more than a mile across and 164 feet deep. About 80 million tons of the island was thrown into the sky. Image by U.S. Air Force 1352nd Photographic Group, Lookout Mountain Station.

069. **MIKE**, Operation IVY (see also #s 065, 066, 067, 068, 070). 7:15am November 1 1952, Eugelab Island, Enewetak Atoll, surface detonation at 10', yield 10.4 megatons. The *Mike* debris cloud and stem about 10 minutes after detonation, seen from a ship. The "cauliflower" structure and "skirt" and "bell" condensation structures common to thermonuclear detonations in the humid Pacific can be discerned here. Personnel and all ships were kept 40 miles distant from the deadly blast. Image by U.S. Air Force 1352nd Photographic Group, Lookout Mountain Station.

070. **MIKE**, Operation IVY (see also #s 065, 066, 067, 068, 069). 7:15am November 1 1952, Eugelab Island, Enewetak Atoll, surface detonation at 10', yield 10.4 megatons. Seen in an aerial photograph made at 12,000' from a distance of about 50 miles, the *Mike* cloud has begun to spread in diameter. The cloud would eventually reach an altitude of 142,000' and a width of 100 miles. *Mike* was as crucial to U.S. nuclear weapons development as *Trinity*, the world's first atomic explosion, had been only seven years before, and was 500 times as powerful. Yields of atomic weapons could now be described not only in kilotons of TNT-equivalent force, but in megatons, and the world instantly became a vastly more dangerous place. The Soviets would detonate a solid-fueled boosted fusion device in less than a year, and a true multistage thermonuclear weapon in three. Image by U.S. Air Force 1352nd Photographic Group, Lookout Mountain Station.

071/072. **OAK**, Operation HARDTACK I. 7:30am June 29 1958, Enewetak Atoll lagoon, barge detonation at 6', yield 8.9 megatons. Personnel watch from Parry Island as *Oak*'s condensation cloud grows in the photograph at left, and as its debris cloud towers perhaps 10 miles in height in the image at right. *Oak* produced an underwater crater 204' deep and 5740' in diameter. It was a retest of the two-stage thermonuclear device that had "fizzled" during the *Yellowwood* test (see #084), and its yield was 20% higher than the predicted 7.5 megatons. The test was an early prototype of the W-53 Titan II missile warhead and B-53 strategic bomb, stockpiled from 1962 to 1997 and yielding 9 megatons. It is not clear

at this time if this oldest and highest-yielding weapon still in the U. S. nuclear arsenal is being kept in the reserve stockpile, or has been slated for actual dismantlement. Image by U.S. Air Force 1352nd Photographic Group, Lookout Mountain Station.

073. **MAGNOLIA**, Operation HARDTACK I. 6:00am May 27 1958, Enewetak Atoll, barge detonation at 13', yield 57 kilotons. Seen from Parry Island, personnel observe *Magnolia*'s glowing Wilson cloud, lit by the fireball within. *Magnolia* was a proof-test of the experimental COUGAR device. Image by U.S. Air Force 1352nd Photographic Group, Lookout Mountain Station.

074. **YESO**, Operation DOMINIC (see also #075). 6:01am June 10 1962, 20 miles south of Christmas Island, airdrop detonation at 8325', yield 3 megatons. Seen in an aerial image from about 15,000', *Yeso*'s fireball rises upwards, illuminating Christmas Island 20 miles away. Two ring-like condensation cloud formations are visible. *Yeso* was a weapons-development test of the experimental "16-M" two-stage thermonuclear device, dropped in a Mark-39 bomb casing. The Mark-39 was stockpiled from 1959 to 1960 and yielded 3 megatons. Image by U.S. Air Force 1352nd Photographic Group, Lookout Mountain Station.

075. **YESO**, Operation DOMINIC (see also #074). 6:01am June 10 1962, 20 miles south of Christmas Island, airdrop detonation at 8325', yield 3 megatons. Telephoto image of the *Yeso* fireball rising shortly after detonation, seen from an altitude of about 8000'. Image by U.S. Air Force 1352nd Photographic Group, Lookout Mountain Station.

076. **WAHOO**, Operation HARDTACK I. 1:30pm May 17 1958, Enewetak Atoll, underwater detonation at 500', yield 9 kilotons. Caught just slightly past its apex, *Wahoo*'s water blast begins to fall back to the surface. *Wahoo* was a weapons-effects firing of the Mark-7 bomb in water 3200 feet deep; the Mark-7 was stockpiled from 1952 to 1967 and had a variable yield of 8 to 61 kilotons. Image by U.S. Air Force 1352nd Photographic Group, Lookout Mountain Station.

077. **STARFISH PRIME**, Operation FISHBOWL. 12:00am July 9 1962, Johnston Island, rocket detonation at 248 miles altitude, yield 1.4 megatons. Seen in an aerial photograph, the *Starfish Prime* blast creates an artificial aurora that lasted seven minutes and knocked out electricity in Oahu, Hawaii, 800 miles away. *Starfish Prime* was a high-altitude test using the W-49 warhead to explore electromagnetic pulse (EMP) effects (see *Orange*, #079). The first attempt to launch it failed on June 20, when the rocket's engine stopped working a minute after launch; the missile was destroyed at 30,000 feet without nuclear detonation, but plutonium contamination was found at Sand Island nearby. The W-49 was stockpiled from 1958 to 1975, yielded 1.4 to 5 megatons, and was deployed on Thor, Atlas, Jupiter and Titan intercontinental and intermediate-range ballistic missiles. Image by U.S. Air Force 1352nd Photographic Group, Lookout Mountain Station.

078. **CHECKMATE**, Operation FISHBOWL. 11:30pm October 19 1962, 41 miles off Johnston Island, rocket detonation at 91 miles altitude, yield probably 60 kilotons. Seen in a black and white aerial photograph, *Checkmate* created a green and blue circular formation surrounded by a vivid red ring. Since it detonated above the atmosphere, it did not make a fireball. *Checkmate* was a high-altitude weapons-effects test using a prototype of the W-50 warhead, which was stockpiled from 1963 to 1991, yielded 60 to 400 kilotons, and deployed on Pershing missiles throughout Europe. Image by U.S. Air Force 1352nd Photographic Group, Lookout Mountain Station.

079. **ORANGE**, Operation HARDTACK I. 12:30am August 12 1958, over Johnston Island, rocket detonation at 27 miles altitude, yield 3.8 megatons. Seen from the aircraft carrier *USS Boxer* about a minute after detonation, *Orange* exhibits the unusual shapes and colors typical of very high-altitude detonations. It was a proof-test of the W-39 warhead to discover possible anti-ballistic missile effects. Unexpectedly, the blast curtailed radio communications across the Pacific, blacking out Hawaii for two hours and Australia for nine. It also created another unexpected phenomenon: a giant electromagnetic pulse (EMP) that wreaked havoc with electronic systems below. Military strategists would later envision early use of both effects against a national enemy to gain advantage; see the 1962 *Starfish Prime* (#077) test. World outcry against nuclear testing was mounting; the first test moratorium would occur two months after *Orange*. The W-39 was stockpiled from 1959 to 1965, yielded 3 to 4 megatons, and was a ground-launched cruise missile and surface-to-surface warhead. Image by U.S. Air Force 1352nd Photographic Group, Lookout Mountain Station.

080. **BLUESTONE**, Operation DOMINIC. 5:21 am June 30 1962, 17 miles south of Christmas Island, airdrop detonation at 4980', yield 1.27 megatons. Silhouetting palm trees on Christmas Island, *Bluestone*'s fireball begins its journey upwards; the radioactive debris cloud would rise to 58,000'. *Bluestone* was a prototype test of the W-56 warhead, stockpiled from 1963 to 1993 and yielding 1 to 2 megatons. About a thousand warheads were produced, with 450 remaining in service until 1993; they were deployed on the Minuteman intercontinental ballistic missile. Image by U.S. Air Force 1352nd Photographic Group, Lookout Mountain Station.

081. **TRUCKEE**, Operation DOMINIC. 5:37am June 9 1962, 10 miles south of Christmas Island, airdrop at 6970', yield 210 kilotons. Seen from Christmas Island, *Truckee*'s debris cloud catches the first rays of dawn. Thermonuclear detonations in the humid Pacific created their own localized weather systems; visible in *Truckee*'s cloud are multiple cloud condensation structures known as "bells" and "skirts" , as well as the more familiar "cauliflower" structure. *Truckee* was a prototype test of the W-58 warhead carried on a Polaris A-2 missile. The W-58 was stockpiled from 1964 to 1982, yielded 200 kilotons, and was deployed on submarine-launched ballistic missiles. Image by U.S. Air Force 1352nd Photographic Group, Lookout Mountain Station.

082. **HARLEM**, Operation DOMINIC. 5:37am June 12 1962, 17 miles south of Christmas Island, airdrop detonation at 13,645', yield 1.2 megatons. With its Wilson cloud below seen silhouetting some weather monitoring instruments on Christmas Island, *Harlem*'s fireball rushes upward. *Harlem* was a prototype test of the W-47 warhead. Stockpiled from 1960 to 1974, the W-47 yielded 600 kilotons to 1.2 megatons, and was deployed on the submarine-launched Polaris ballistic missile. Image by U.S. Air Force 1352nd Photographic Group, Lookout Mountain Station.

083. **CACTUS**, Operation HARDTACK I. 6:15am May 6 1958, Runit Island, Enewetak Atoll, surface detonation at 3', yield 18 kilotons. The *Cactus* detonation flashes into the morning sky, slightly below the brush-filled horizon of a neighboring island. *Cactus*' crater was 37' deep and 346' wide; in 1979 the U. S. Government used it to bury 110,000 cubic yards of radioactive soil from other islands in Enewetak, topping it with concrete. *Cactus* was a test of the primary fission stage of a Mark-43 thermonuclear bomb, which was stockpiled from 1961 to 1991 and yielded 70 kilotons to 1 megaton. Image by U.S. Air Force 1352nd Photographic Group, Lookout Mountain Station.

084. **YELLOWWOOD**, Operation HARDTACK I. 2:00pm May 27 1958, Enewetak Atoll, barge detonation at 10', yield 330 kilotons. *Yellowwood*'s detonation illuminates low afternoon cloud cover. *Yellowwood* was a "fizzle", due to substandard second-stage thermonuclear burning; its predicted yield was 2.5 megatons. The problem was successfully corrected and the device enlarged in the 8.9 megaton *Oak* test (see #s 071,072) that followed a month later. *Yellowwood* was an early prototype of the W-53 Titan II missile warhead and B-53 strategic bomb, stockpiled from 1962 to 1997 and yielding 9 megatons. It is not clear at this time if this oldest and highest-yielding weapon in the U. S. nuclear arsenal is being kept in the reserve stockpile or has been slated for dismantlement. Image by U.S. Air Force 1352nd Photographic Group, Lookout Mountain Station.

085. **FRIGATE BIRD**, Operation DOMINIC. 2:30pm May 6 1962, Pacific Ocean about 500 miles east–northeast of Christmas Island, rocket detonation at 11,000', yield 600 kilotons. In a photograph made from the periscope of the submarine *USS Carbonero*, *Frigate Bird*'s debris cloud rises less than 30 miles away. The only U.S. test of a ballistic missile with a live nuclear warhead, *Frigate Bird* was launched from the *USS Ethan Allen* and flew 1174 miles in space before atmospheric re-entry and detonation. It proof-tested the W-47 warhead, stockpiled from 1960 to 1974 and yielding 600 kilotons to 1.2 megatons. It was deployed on the Polaris submarine-launched ballistic missile, and effected major technological advances in small size, low weight and high-yield weapons that pervade the U.S. nuclear missile arsenal to this day. Image by U.S. Air Force 1352nd Photographic Group, Lookout Mountain Station.

086. **MOHAWK**, Operation REDWING (see also #087). 6:06am July 3 1956, Eberiru Island, Enewetak Atoll, tower detonation at 300', yield 360 kilotons. Personnel observe *Mohawk*'s fireball and ring-like condensation cloud structure from Japtan Island. *Mohawk* was a test of a two-stage thermonuclear device; its crater was 8' deep and 1340' wide. Image by U.S. Air Force 1352nd Photographic Group, Lookout Mountain Station.

087. **MOHAWK**, Operation REDWING (see also #086). 6:06am July 3 1956, Eberiru Island, Enewetak Atoll, tower detonation at 300', yield 360 kilotons. Seen from a nearby island, *Mohawk*'s fireball and coral-filled stem roil upwards. Image by U.S. Air Force 1352nd Photographic Group, Lookout Mountain Station.

088. **ZUNI**, Operation REDWING. 5:56am May 28 1956, Eninman Island, Bikini Atoll, surface detonation at 9', yield 3.5 megatons. Aerial image of the *Zuni* fireball obscured by thick cloud cover, showing two rocket smoke trails used to photographically measure the explosion's invisible air shock wave. The blast created a crater 100' deep and a half-mile in diameter; its radioactive debris cloud rose to a height of 85,000' and was 15 miles wide. *Zuni* was the first test of a three-stage "clean" thermonuclear device, gaining 85% of its energy from fusion rather than fission, but the term "clean" is relative, certainly: as in the *Bravo* radiological disaster two years earlier, fallout from *Zuni* rained on an unfortunate Japanese ship in the region, the *Mizuo Maru*, which was sailing 150 miles distant. Crewmembers suffered an acute shortage of white blood corpuscles. *Zuni* was a prototype of the Mark-41 bomb. The Mark-41 was stockpiled from 1960 to 1976, and at a yield of 25 megatons was the most destructive weapon the United States ever produced, about 65% larger than 15-megaton *Bravo*, its largest test (see #s 093,099). The Soviet Union airdropped a 50 megaton nuclear bomb over the Arctic in 1961, detuned from its full capacity of 100 megatons. A single 100 megaton bomb carries the explosive power of 6666 Hiroshima bombs. Image by U.S. Air Force 1352nd Photographic Group, Lookout Mountain Station.

089. **AZTEC**, Operation DOMINIC. 6:01am April 27 1962, 10 miles south of Christmas Island, airdrop at 2610', yield 410 kilotons. Aerial image of the *Aztec* fireball rising through early morning cloud cover, some of its own making. Its radioactive debris cloud rose to a height of 60,000'. *Aztec* was a prototype test of the W-50 thermonuclear warhead, stockpiled from 1963 to 1991, yielding 60–400 kilotons, and deployed on Pershing missiles throughout Europe. Image by U.S. Air Force 1352nd Photographic Group, Lookout Mountain Station.

090. **ITEM**, Operation GREENHOUSE. 6:17am May 25 1951, Enjebi Island, Enewetak Atoll, tower detonation at 200', yield 45.5 kilotons. Seen from a neighboring island, *Item*'s fireball rushes upwards, creating a ring-like condensation cloud above it. *Item* was the first test of the feasibility of using deuterium-tritium gas in the core of a weapon to enhance fission, a principle known as "fusion boosting" that radically increased efficiency of the explosion; predicted yield without boosting was 50% less. The technique led to "dial-a-yield" capability in later weapons, where the power of the explosion could be controlled by the amount of gas added. Image by U.S. Air Force 1352nd Photographic Group, Lookout Mountain Station.

091. **APACHE**, Operation REDWING. 6:06am July 9 1956, in the *Mike* test crater of the former island of Eugelab, Enewetak Atoll, barge detonation at 15', yield 1.85 megatons. Aerial view of *Apache*'s glowing Wilson condensation cloud; another island in the atoll is visible to the south in the center foreground. The radioactive debris cloud rose to a height of 85,000', and produced exceptionally heavy fallout in the northern islands of Enewetak. *Apache* was a prototype test of the W-27 thermonuclear warhead, stockpiled from 1958 to 1965 and yielding 2 megatons. Image by U.S. Air Force 1352nd Photographic Group, Lookout Mountain Station.

092. **CHEROKEE**, Operation REDWING. 5:51am May 21 1956, off Namu Island, Bikini Atoll, airdrop detonation at 4350', yield 3.8 megatons. In the first U.S. airdrop of a thermonuclear weapon, *Cherokee*'s fireball rises upwards in this aerial photographic view partially obscured by ring-like condensation cloud structures. To the right are three smoke trail lines from rockets launched just before detonation to help cameras measure the progression of the explosion's invisible air shock wave. The bomb was mistakenly released from a B-52 bomber four miles off target, and as a result most weapons-effects data was lost. *Cherokee* proof-tested the new Mark-39 thermonuclear bomb, stockpiled from 1957 to 1966 with a variable yield of 3–4 megatons, and also pointedly demonstrated to the Soviet Union that the United States now possessed deliverable hydrogen bombs of massive destructive capacity. The radioactive debris cloud rose to a height of 94,000' and had a diameter of 25 miles. Seven minutes after detonation the interior of the cloud was measured at 20,000 roentgens per hour – a cumulative dose of just 500 roentgens immediately kills half those exposed to it. Image by U.S. Air Force 1352nd Photographic Group, Lookout Mountain Station.

093. **BRAVO**, Operation CASTLE (see also #099). 6:45am March 1 1954, artificial island 3000' off Nam Island, Bikini Atoll, surface detonation at 7', yield 15 megatons. The largest U.S. nuclear device ever exploded,

Bravo's fireball expands to almost 4 miles width within a second of detonation and begins its long journey upwards. The flash was seen in Okinawa, 2600 miles away. The blast crater was 1.25 miles wide and 250' deep; the top of the debris cloud carrying the vaporized reef would ultimately reach 130,000' and a diameter of 66 miles. The cloud bottom itself rose above 55,000'. The first solid-fueled thermonuclear device, Bravo was 2.5 times more powerful than predicted. The unexpectedly high yield, combined with a failure to both postpone the test in the face of unfavorable weather conditions and perform proper pre-test evacuations, made Bravo the worst radiological disaster in U.S. testing history. Islands close to ground zero received over 5000 roentgens/hour of radiation, and the island of Rongelap 120 miles east received up to 1000 roentgens/hour. 28 Americans and 236 Marshallese were badly sickened and were finally evacuated on March 3. All the islands of Bikini Atoll were uninhabitable for the rest of Operation Castle. Rongelap islanders were not allowed to return until 1957, and Bikini Atoll remains uninhabitable to this day due to radioactive cesium-137 soil contamination. The Bravo test advanced work on the Mark-21 bomb, stockpiled from 1955 to 1957 and carrying a yield of 4 to 5 megatons. 275 bombs were produced; in 1957 the Mark-21 was converted to the Mark-36 design. Image by U.S. Air Force 1352nd Photographic Group, Lookout Mountain Station.

094. **SUNSET**, Operation DOMINIC. 6:33am July 10 1962, Christmas Island area, airdrop detonation at 5000', yield 1 megaton. Sunset's fireball rises upwards, surrounded by multiple ring condensation clouds, into the humid morning air. Its radioactive cloud rose to 60,000'. Sunset was prototype test of the W-59 warhead, stockpiled from 1962 to 1969 with a yield of 1 megaton, and was deployed on intercontinental and ballistic missiles. About 150 W-59 warheads were produced. Image by U.S. Air Force 1352nd Photographic Group, Lookout Mountain Station.

095. **ROMEO**, Operation CASTLE (see also #096). 6:30am March 27 1954, in Bravo crater on former island of Nam, Bikini Atoll, barge detonation at 14', yield 11 megatons. Seen from a neighboring island, Romeo's fireball pushes upwards, capped by a ring-like condensation cloud. A minute after detonation the debris cloud reached 44,000' and was 6 miles wide; ten minutes later it had grown to 60 miles in diameter. It would eventually rise to a height of 110,000'. Romeo was a proof-test of the Mark-17/24 bomb, stockpiled from 1954 to 1957 and yielding 10 to 15 megatons. Image by U.S. Air Force 1352nd Photographic Group, Lookout Mountain Station.

096. **ROMEO**, Operation CASTLE (see also #095). 6:30am March 27 1954, in Bravo crater on former island of Nam, Bikini Atoll, barge detonation at 14', yield 11 megatons. Aerial telephoto image of the Romeo fireball, seen with a portion of a condensation cloud structure above. The second U.S. solid-fueled thermonuclear device, Romeo's yield was three times larger than predicted and used plentiful, unprocessed natural lithium as its fusion fuel. It was the first barge detonation in the Pacific Proving Grounds, a practice which would quickly become the norm for high-yield thermonuclear surface tests to save the rapidly-vaporizing islands of the Bikini and Enewetak Atolls. Image by U.S. Air Force 1352nd Photographic Group, Lookout Mountain Station.

097. **DAKOTA**, Operation REDWING. 6:06am June 26 1956, 5000' off Yurochi Island in Bikini Atoll lagoon, barge detonation at 15', yield 1.1 megatons. Dakota's fireball, encircled by Wilson condensation strata, blasts up through a layer of early morning cloud cover in this aerial view. Dakota was a prototype test of the W-28 warhead, stockpiled from 1958 to 1991, and variably yielding from 70 kilotons to 1.45 megatons. The most versatile and widely used of any U.S. thermonuclear weapon, it was manufactured in five models and had 20 different variants. The test device weighed 1797 pounds and had a diameter of 20 inches and a length of about 5 feet. Dakota's yield was 25% more than predicted, and a number of weapons-effects over-flight aircraft were extensively damaged from thermal and blast effects, though all made safe landings. The radioactive debris cloud rose to a height of 81,000', and its upper umbrella extended to a width of 200 miles. Image by U.S. Air Force 1352nd Photographic Group, Lookout Mountain Station.

098. **APACHE**, Operation REDWING. 6:06am July 9 1956, in the Mike crater of the former island of Eugelab, Enewetak Atoll, barge detonation at 15', yield 1.85 megatons. Partially obscured by weather of its own making and early morning cloud cover, Apache's glowing fireball rises skywards, followed by a large debris stem. Its cloud would eventually rise to a height of 85,000', and produce exceptionally heavy fallout in the northern islands of the Atoll. Military landing craft fill the foreground view in this surface view. Apache was a prototype test of the Mark-27 thermonuclear warhead, stockpiled from 1958 to 1965, with a yield of 2 megatons. Image by U.S. Air Force 1352nd Photographic Group, Lookout Mountain Station.

099. **BRAVO**, Operation CASTLE (see also #093). 6:45am March 1 1954, artificial island 3000' off Nam Island, Bikini Atoll, surface detonation at 7', yield 15 megatons. Red aerial image made with special film at a height of about 40,000' a few minutes after detonation, showing Bravo's fireball and debris cloud with two condensation ring strucures and several ice caps. The cloud would eventually reach 130,000' and a diameter of 66 miles. Bravo was the largest U.S. test ever detonated, and was about 2.5 times more powerful than predicted. It was also the worst radiological disaster in U.S. history. 85 miles northeast of the detonation, the Japanese fishing vessel Daigo Fukuryu Maru (Fifth Lucky Dragon) was blanketed with such strong fallout radiation that all 23 crewmembers were sickened with an estimated exposure of 130 to 450 roentgens; radioman Aikichi Kuboyama would die on September 23. The remaining crewmembers would leave hospital eight months later. After this disaster, the exclusion zone around the Castle tests was increased to a size measuring about 1% of the Earth's total surface area. Bravo showed that a high-yield surface detonation could create lethal radiological contamination 120 miles downwind of the blast point, and dangerous contamination to 250 miles downwind. The Bravo test advanced work on the Mark-21 bomb, stockpiled from 1955 to 1957 and carrying a yield of 4–5 megatons. Image by U.S. Air Force 1352nd Photographic Group, Lookout Mountain Station.

100. **YANKEE**, Operation CASTLE. 6:10am May 5 1954, Bikini Lagoon, barge detonation at 14', yield 13.5 megatons. In this 15,000' aerial view of the second-largest test ever detonated by the United States, Yankee's fireball rolls upwards surrounded by three condensation ring cloud structures. Within a minute of detonation, the cloud reached 34,000' and was 6.5 miles wide; after ten minutes the cloud grew to 51 miles in diameter. It would eventually rise to a height of 110,000'. Yankee was a proof-test of the Mark-17/24 bomb, stockpiled from 1954 to 1957 and yielding 10 to 15 megatons. It was similar to the Romeo test but used partially enriched, instead of natural, lithium in its fusion fuel. This led to a 61% increase in the fusion yield. As a whole, the six tests of Operation Castle were expected to generate 23 megatons of energy, but they wound up creating 48.2 megatons. Two years later the next series of high-yield thermonuclear tests in the Pacific, Operation Redwing, would be put on an "energy budget." Image by U.S. Air Force 1352nd Photographic Group, Lookout Mountain Station.

CHRONOLOGY

1938
MARCH 11: Adolf Hitler invades Austria, proclaiming its political and geographic union with Germany.
SEPTEMBER 30: Britain and France submit to Nazi demands for cessation of the Sudetenland to Germany by Czechoslovakia.
DECEMBER 10: Italian Enrico Fermi receives Nobel Prize in physics for discovering new radioactive elements and neutron-capture nuclear reactions. Sails for America thereafter, permanently fleeing Fascist Italy.
DECEMBER 19: Otto Hahn and Fritz Strassmann, scientists at the Kaiser Wilhelm Institute of Chemistry in Berlin, discover fission in uranium. Hahn describes the results in a letter written the same day to his colleague Lise Meitner, now fled to Denmark, who discusses it that Christmas with Otto Frisch. Frisch twice discusses the fission theory and its attendant energy release with Danish physicist Niels Bohr in early January, before Bohr sails for America to attend the Washington Conference on Theoretical Physics. All realize the full implications of the discovery.

1939
JANUARY 6: Strassmann's and Hahn's article printed in Berlin.
JANUARY 13: Otto Frisch demonstrates in Denmark that the uranium atom can be split.
JANUARY 22: Physicists at Columbia University split the uranium atom in the United States.
JULY 16: Exiled physicists Leo Szilard and Eugene Wigner visit Albert Einstein to review the recent uranium fission results with him. Seeing the gravity of the situation, Einstein offers to help gain the attention of the United States government.
AUGUST 2: Einstein writes a now-famous two-page letter to President Franklin D. Roosevelt outlining the immense potential power of the nuclear fission chain reaction in uranium, its possible uses as a weapon, recent German quarantining of Czechoslovakian uranium mines, the German pedigree of the fundamental research breakthrough, and the desirability of a large-scale, government-funded project to advance U.S. experimental work on the subject.
AUGUST 23: The Soviet Union and Germany sign a non-aggression pact.
SEPTEMBER 1: Germany invades Poland; two days later Britain and France declare war on Germany. World War II begins; United States remains neutral.
SEPTEMBER 17: Poland invaded by Soviet Union.
SEPTEMBER 27: Poland surrenders.
OCTOBER 1: Financier Alexander Sachs, friend to both Roosevelt and Einstein, delivers Einstein's August 2 letter to Roosevelt. The President remarks: "Alex, what you are after is to see that the Nazis don't blow us up." Sachs replies: "Exactly."

1940
APRIL 9: Norway and Denmark invaded by Germany; Norway surrenders June 9.
MAY 10: Winston S. Churchill becomes Prime Minister of Great Britain after resignation of Neville Chamberlain.
MAY 15: Holland surrenders.
MAY 25: Belgium surrenders.
MAY 28: British army evacuated from France at Dunkirk.
JUNE 14: Paris taken by German army.
JUNE 28: Roosevelt establishes Office of Scientific Research and Development under the direction of Vannevar Bush to coordinate nuclear research in the United States.
JULY: German physicist Werner Heisenberg and colleagues, with support of the German War Office, begin construction in Berlin of a clandestine sub-critical uranium burner. Germany now controls a Norwegian heavy water plant used to enrich uranium, the world's only, and thousands of tons of uranium ore via Belgium and the Belgian Congo.
AUGUST 8: Germany attacks England and the Battle of Britain begins in the air.
NOVEMBER 5: Roosevelt is elected to the U.S. presidency for the third time.

1941
JUNE 22: Germany invades the Soviet Union; Churchill offers Soviets assistance.
SEPTEMBER 5: German army besieges Leningrad; 600,000 Russian prisoners taken through October.
DECEMBER 7: Japan destroys U.S. Navy fleet at Pearl Harbor, simultaneously attacking Hawaii, Hong Kong, Malaysia, Singapore and the Philippines. U.S. Congress declares war on Japan and Germany.

1942
MARCH 9: Vannevar Bush tells Roosevelt that the United States might succeed in producing an atomic bomb by the year 1944, and suggests that the U.S. army should assume overall responsibility for research and development.
JUNE 13: Roosevelt approves a plan for major expansion of atomic bomb research work, approving funds to build a gaseous diffusion uranium separation plant in Oak Ridge, Tennessee, and pilot plants for three other methods of uranium enrichment.
SEPTEMBER 7: Army Brigadier General Leslie R. Groves is made head of the Manhattan Project, created June 17 to oversee all aspects of the U.S. atomic bomb program.
OCTOBER 8: Groves selects J. Robert Oppenheimer to run a laboratory to design and develop the atomic bomb.
NOVEMBER 16: Groves, Oppenheimer and associates select Los Alamos, New Mexico as the site for the lab.
DECEMBER 2: Following Leo Szilard's theories, Enrico Fermi oversees a working atomic "pile" of enriched uranium into criticality at the University of Chicago. The atomic age begins.

1943
FEBRUARY 2: Germans surrender to the Soviet army at Stalingrad; 91,000 troops are captured.
FEBRUARY 16: Six British-trained Norwegian soldiers parachute into Norway and destroy the heavy-water production factory at Vemork, crucial to the German atomic bomb effort.

1944
JUNE 6: D-Day: Allied forces land in Normandy France.
JUNE 12: Germans begin using a flying bomb created by Wernher von Braun, who would go on to design rockets and nuclear ballistic missiles for the United States after the war.
JUNE 22: Stalin begins general offensive to the West and quickly reaches Warsaw; takes Bulgaria and Rumania.
AUGUST 14: Klaus Fuchs, the German-born spy who would eventually pass crucial atomic secrets to the Soviets, arrives at Los Alamos as a member of the British mission to the Manhattan Project.
AUGUST 25: Allies march through Paris.
NOVEMBER 2: U.S. takes Saipan in the Mariana Islands; at 1300 miles it is now within bombing range of Tokyo.
NOVEMBER: Roosevelt elected President for a fourth term.

1945
U.S. HAS 6 STOCKPILED NUCLEAR WEAPONS
FEBRUARY 18: U.S. attacks the Iwo Jima Islands, defended to the last man by 23,000 Japanese soldiers and finally taken March 14.
MARCH 15: German uranium-thorium manufacturing facility at Oranienburg destroyed by Allied bombing.
APRIL 12: Franklin D. Roosevelt dies and Vice-President Harry S. Truman assumes the U.S. presidency, wholly unaware of the Manhattan Project or any national nuclear research.
APRIL 16: Berlin attacked by Soviets from East.
APRIL 23: Allies reach Berlin from West.
APRIL 30: Hitler commits suicide.
MAY 8: Germany unconditionally surrenders; Europe celebrates.
JUNE 22: Germany divided into occupation zones under the aegis of the U.S., France, Britain, and the Soviet Union.
JULY 16: U.S. conducts the first of a total of 1054 national nuclear tests, inaugurating the atomic age with a 21-kiloton plutonium-239 implosion bomb test code-named *Project Trinity* at Alamogordo, New Mexico. Costing some $2 billion in 1945 dollars and employing upwards of 100,000 people, the Manhattan Project proves successful. 164 military personnel attend.
JULY 17–AUGUST 2: Truman, Stalin, and Churchill attend the Potsdam Conference, warning Japan on the last day to surrender or suffer "prompt and utter destruction." Truman hints to Stalin that the U.S. possesses a new weapon of unthinkable destructive power, something Stalin already knows through espionage.
AUGUST 6: At 8:15am the United States drops *Little Boy*, an atomic bomb with a destructive force of 15,000 tons of TNT (15 kilotons), on the Japanese city of Hiroshima. A year later Hiroshima City Hall tallies the results of the explosion: 122,338 people dead or missing, 30,524 seriously wounded, and 48,606 slightly wounded, for a total of 201,468 casualties. Over the next five years the dead would come to number over 200,000. The crude gun-type uranium bomb harnesses only 1.3% of the atomic energy in its core. Long-term effects of radiation would begin to appear a decade later.
AUGUST 9: At 11:02am the United States drops *Fat Man*, an atomic bomb with a destructive force of 21,000 kilotons, on the Japanese city of Nagasaki. The Japanese verified immediate casualties at 25,680 people dead or missing and 23,245 wounded. Later estimates of the total number killed from immediate and delayed effects vary from 60,000 to 90,000 people. The plutonium implosion bomb utilizes 17% of the fission energy in its core.
AUGUST 14: Japan agrees to surrender.
AUGUST 20: Stalin accelerates the Soviet nuclear weapons program in the light of Hiroshima and Nagasaki, placing his brutal secret police chief Lavrenti Beria in charge.
SEPTEMBER 2: Japan formally surrenders to the United States in Tokyo harbor on the battleship *USS Missouri*. World War II ends.
DECEMBER 20: U.S. Congress transfers Manhattan Project facilities and mandate to a new civilian agency, the Atomic Energy Commission (A.E.C.), which would secretively oversee U.S. nuclear matters until its dissolution in 1974.

1946
U.S. HAS 11 STOCKPILED NUCLEAR WEAPONS
JUNE 14: U.S. formally presents a plan for international control of atomic weapons to the United Nations.
JUNE 30: U.S. Operation *Crossroads* begins on Bikini Atoll in the Marshall Islands; two weapons-effects tests conducted. It is the largest U.S. peacetime military operation to date, with 40,112 military personnel attending.

1947
U.S. HAS 32 STOCKPILED NUCLEAR WEAPONS
MARCH 5: Soviet Union refuses international control of atomic research.
JULY: George F. Kennan of the U.S. State Department introduces the now-famous policy of U.S. "containment" towards the Soviet Union in *Foreign Affairs* magazine, analyzing the methods and psychology of Soviet diplomacy.

1948
U.S. HAS 110 STOCKPILED NUCLEAR WEAPONS
FEBRUARY: J. Robert Oppenheimer declares in a magazine interview: "In some crude sense, which no vulgarity, no humor, no overstatement can quite extinguish, the physicists have known sin and this is a knowledge they cannot lose."
MARCH: U.S. Joint Chiefs of Staff prepare "Operation Half-Moon" which plans for a full U.S. nuclear attack on the Soviet Union if it invades Western Europe.
JULY 24: Soviet Union blockades West Berlin, and a year-long airlift of supplies to the city by U.S. and British aircraft begins the next day.
NOVEMBER: Democrat Harry Truman re-elected to the U.S. presidency by a close margin.

1949
U.S. HAS 235 STOCKPILED NUCLEAR WEAPONS; U.S.S.R. HAS 1
APRIL 4: North Atlantic Treaty Organization (NATO) is formed by the U.S. and Western Europe.
APRIL 15: U.S. Operation *Sandstone* begins on Enewetak Atoll in the Marshall Islands; three tests conducted; 11,782 military personnel attend.
JUNE 17: Czechoslovakia taken by Soviet-backed communist officials; only uranium mines in Europe now in Soviet control.
MAY: British government announces its intention to build an atomic bomb.
AUGUST 29: Soviet Union detonates the first of a total of 715 national nuclear tests, *Joe 1*, with a yield of 22 kilotons, totally surprising U.S. authorities who estimated such a detonation to be at least two years away. The U.S.S.R. formally admits the test seven months later. Physicists Edward Teller, Ernest Lawrence and Luis Alvarez begin lobbying the U.S. government to support research on thermonuclear fusion weaponry, known as the "hydrogen" bomb.
DECEMBER 8: Nationalist China's government under Chiang Kai-Shek collapses and Chinese Communists take the country.

1950
U.S. HAS 369 STOCKPILED NUCLEAR WEAPONS; U.S.S.R. HAS 5
JANUARY 31: Truman orders the Atomic Energy Commission to accelerate thermonuclear weapon development, culminating a heated debate in the ranks of the Commission and elsewhere. J. Robert Oppenheimer opposes the decision, along with Albert Einstein and the president of Harvard University.
FEBRUARY 3: German-born nuclear physicist Klaus Fuchs, a member of the Anglo-American team that developed the atomic bomb at Los Alamos beginning in 1943, is arrested and found guilty a month later of having passed crucial atomic secrets to the Soviets.
JUNE 25: Communist North Korean forces invade the Republic of South Korea, beginning the Korean War, which continues until July 1953. Two days later President Truman orders the U.S. military to support South Korea. Many in the U.S. argue that North Korea was emboldened by Soviet possession of the atomic bomb.
DECEMBER: Atomic Energy Commission takes over the former Las Vegas Bombing and Gunnery Range, creating a U.S. continental nuclear testing site known as the Nevada Test Site 63 miles from Las Vegas. In the race to build the hydrogen bomb and new tactical atomic weapons in the face of new Soviet atomic capability, national concerns of testing security, ease of use, and economy trump those of the health of American citizens. 106 above-ground tests were to rain dangerous radioactive fallout across the nation until the Limited Test Ban Treaty was signed in 1963 and all further testing was conducted underground. A total of 928 nuclear tests occur in Nevada until 1992.

1951
U.S. HAS 640 STOCKPILED NUCLEAR WEAPONS; U.S.S.R. HAS 25
JANUARY 27: U.S. Operation *Ranger* begins at the Nevada Test Site; five nuclear tests conducted; 266 military personnel attend.
APRIL 8: U.S. Operation *Greenhouse* begins at Enewetak Atoll; four tests conducted; 7,590 military personnel attend.
SEPTEMBER 24: Soviet Union detonates its second atomic device, followed by its first airdropped bomb three weeks later.
OCTOBER 22: U.S. Operation *Buster-Jangle* begins at Nevada Test Site; five weapons-development tests and two weapons-effects tests conducted; 7,812 military personnel attend.

1952
U.S. HAS 1005 STOCKPILED NUCLEAR WEAPONS; U.S.S.R. HAS 50
APRIL 1: U.S. Operation *Tumbler-Snapper* begins at the Nevada Test Site; two weapons effects tests, six weapons development tests; 8,710 military personnel attend.
OCTOBER 3: The United Kingdom conducts the first of a total of 45 national nuclear tests with a 25-kiloton detonation off Western Australia.
OCTOBER 31: U.S. Operation *Ivy* begins at Enewetak Atoll with the detonation of *Mike*, the world's first high-yield two-stage thermonuclear device. At 10.4 megatons, the experimental liquid deuterium device exceeds the explosive power of all ordinance detonated in World Wars I and II combined, operating on the same energy fusion principles as the sun and stars. 11,650 military personnel attend. The nuclear arms race between the U.S. and the U.S.S.R. begins in earnest; for the next forty years, nuclear Armageddon will be discussed as a real possibility at the highest levels of both nation's governments.
NOVEMBER: Republican General Dwight D. Eisenhower, former Commander-in-Chief of U.S. forces in Europe during World War II, is elected president of the United States.

1953
U.S. HAS 1436 STOCKPILED NUCLEAR WEAPONS; U.S.S.R. HAS 120
MARCH 5: Josef Stalin dies at age 73, after ruling the Soviet Union for 25 years. The volatile and blustering Nikita Khrushchev is named first Secretary of the Communist Party.
MARCH 17: U.S. Operation *Upshot-Knothole* begins at the Nevada Test Site; a total of 11 tests are detonated; 18,000 military personnel attend. Tests *Simon*, *Harry*, *Dixie* and *Nancy* create deadly radioactive fallout that affects the United States from Utah to Massachusetts. Protest ensues and the Atomic Energy Commission, in disregard of its own experts, consistently denies there is any danger from U.S. continental testing.
JULY 27: U.S. and North Korea sign an armistice ending the Korean War.
AUGUST 12: U.S.S.R. detonates a "boosted" fission device, with a yield of 400 kilotons, followed by four more nuclear tests that year.
OCTOBER 30: Eisenhower announces fundamental U.S. National Security Council policy involving use of nuclear weapons at all levels.

1954
U.S. HAS 2063 STOCKPILED NUCLEAR WEAPONS; U.S.S.R. HAS 150
JANUARY 4: U.S. Secretary of State John Foster Dulles outlines the doctrine of "Massive Retaliation," wherein the United States might choose to respond to communist-led conventional force aggression with "any means at its disposal." By 1960, facing a growing Soviet nuclear arsenal bolstered by intercontinental ballistic missiles (ICBMs), U.S. policy shifts to a policy of "flexible response", thereby avoiding reflexive nuclear holocaust.
JANUARY 21: First nuclear-powered submarine *Nautilus* is launched by U.S. Navy.
JANUARY 29: Atomic Energy Commission by a vote of 4 to 1 revokes J. Robert Oppenheimer's U.S. security clearances on the grounds of past communist political leanings and his opposition to the development of the hydrogen bomb. Edward Teller's testimony against Oppenheimer is a major factor in the decision.
MARCH 1: U.S. Operation *Castle* begins on Bikini Atoll with test *Bravo*, at 15 megatons the largest nuclear weapon the U.S. would ever detonate. Testing new solid-fuel lithium deuteride thermonuclear technology, the power of the reaction exceeds estimations by 250% and deadly radioactive fallout blankets neighboring islands and a Japanese fishing boat in nearby waters, killing one crewmember and sickening them all. Worldwide protest against atmospheric testing ensues. Six hydrogen bomb tests occur, with a total yield of 48.2 megatons; 12,700 military personnel attend.
SEPTEMBER 14: U.S.S.R. begins the first of ten nuclear weapons tests for the year.

1955
U.S. HAS 3057 STOCKPILED NUCLEAR WEAPONS; U.S.S.R. HAS 200
FEBRUARY 18: Operation *Teapot* begins at the Nevada Test Site with a total of 14 tests conducted to further development of ICBMs with thermonuclear warheads; 8,700 military personnel present.
MAY 9: West Germany is admitted to NATO, and five days later eight European Communist powers sign the Warsaw Pact.
MAY 14: U.S. Operation *Wigwam* occurs in the Pacific 400 miles southwest of San Diego; a deep underwater nuclear-effects test with a yield of 30 kilotons; 6800 military personnel attend.
JULY 29: U.S.S.R begins the first of six 1955 nuclear weapons tests, culminating in the detonation of its first two-stage thermonuclear device, an airdropped bomb with a yield of 1.6 megatons, on November 22.
NOVEMBER 26: U.S. Air Force takes control of all U.S. nuclear missiles with a range greater than 2000 miles.

1956
U.S. HAS 4618 STOCKPILED NUCLEAR WEAPONS; U.S.S.R. HAS 426
FEBRUARY 2: U.S.S.R. begins the first of nine 1956 nuclear weapons tests.
MAY 4: U.S. Operation *Redwing* begins in the Pacific; 17 atmospheric tests occur with a total yield of 20.9 megatons; 11,350 personnel attend. The first U.S. airdrop of a thermonuclear weapon occurs with 3.8 megaton *Cherokee*.
JUNE: U.S. begins U-2 spy plane reconnaissance flights over the Soviet Union.
NOVEMBER: Eisenhower wins re-election to the U.S. presidency, soundly beating Democrat Adlai Stevenson, who runs on a platform of an international ban on nuclear testing. Stevenson specifically links bone cancer to radioactive strontium-90 fallout from testing.

1957
U.S. HAS 6444 STOCKPILED NUCLEAR WEAPONS; U.S.S.R. HAS 660
JANUARY 14: U.S. United Nations Ambassador Henry Cabot Lodge presents a plan for nuclear disarmament, linking a test ban with cessation of production of nuclear weapons materials.
JANUARY 19: U.S.S.R. begins the first of sixteen 1957 nuclear weapons tests focusing on warheads for tactical usage.
MAY 28: U.S. Operation *Plumbbob* begins at the Nevada Test Site, with a total of 29 detonations; 13,300 military personnel attend. The largest U.S. continental atmospheric test, 74 kiloton *Hood*, occurs on July 5. *Hood*, *Smoky*, and *Charleston*, all created by Edward Teller's University of California Radiation Laboratory, are also the first actual thermonuclear devices detonated in Nevada; the U.S. government would strenuously deny that such thermonuclear explosions occurred on the continent until 1979. The A.E.C. discusses conducting Operation *Plumbbob* in the Pacific for safety reasons, but decides against it due to the extra cost and the additional delays incurred to weapons development, now pressured by the strong possibility of a worldwide nuclear test ban.
OCTOBER 4: Soviet Union launches the first Earth satellite, *Sputnik 1*, using its SS-6 ICBM, followed by another with a dog aboard on November 3. Missile-borne nuclear weapons can now be launched from within the Soviet Union to hit targets deep in the United States. The U.S. would not successfully test its first ICBM, the Atlas B, until 13 months later. Both ICBMs are liquid-fueled and cannot be fired on short notice.
NOVEMBER 8: U.K. detonates its first high-yield thermonuclear device at Christmas Island, a part of the Line Islands in the Pacific Ocean. Yield is 1.8 megatons, and is the culmination of six other U.K. tests in 1957.

1958
U.S. HAS 9822 STOCKPILED NUCLEAR WEAPONS; U.S.S.R. HAS 869
JANUARY 4: U.S.S.R. begins the first of what will eventually be 34 atmospheric nuclear weapons tests for the year.
JANUARY 31: U.S. successfully orbits its first Earth satellite, *Explorer 1*, under the direction of Wernher von Braun, using his Jupiter C ICBM.
MARCH 27: The unpredictable Nikita Khrushchev becomes Premier of the Soviet Union; four days later he obtains national approval to suspend for the indefinite future Soviet nuclear weapons testing if other countries follow suit. The Soviets unilaterally suspend nuclear testing, but Khrushchev pursues a policy of nuclear threats, assertions and bluffing, exploiting the U.S. impression of Soviet ICBM superiority to the fullest. The U.S. would not discover for two years that the Soviets only had four deployable ICBMs until mid-1960.
APRIL 29: U.S. Operation *Hardtack I* begins in the Pacific; 31 nuclear detonations ensue; 16,000 military personnel attend.
AUGUST 22: Eisenhower announces that the U.S. will begin a nuclear testing moratorium on October 31 to last at least a year, during negotiations on monitoring a ban and disarmament agreements, so long as the Soviet Union also refrains during negotiations. This moratorium was to eventually last 34 months.
AUGUST 27: U.S. Operation *Argus* (clandestine until announcement in 1959) begins; three 300-mile high 1–2 kiloton rocket detonations in the South Atlantic designed to create artificial Van Allen Belts around the Earth; 4,500 military personnel attend.
SEPTEMBER 12: U.S. Operation *Hardtack II* begins at the Nevada Test Site; 17 nuclear detonations and 19 nuclear safety tests ensue before the October 31 U.S. moratorium. 1,650 personnel attend.
SEPTEMBER 23: Last atmospheric test detonated by the United Kingdom; thereafter it pursues only joint U.K.–U.S. operations.
SEPTEMBER 30: Khrushchev breaks his unilateral March moratorium with 19 nuclear testing events through October 31.
OCTOBER 1: Eisenhower creates the National Aeronautics and Space Administration (NASA), a civilian agency focusing on peaceful uses and exploration of cosmic space.
OCTOBER 5: Soviet Union presents a draft resolution at the United Nations calling for a permanent ban on all nuclear weapons testing.

OCTOBER 31: U.S., U.K. and the U.S.S.R. begin nuclear test ban treaty negotiations in Geneva.
NOVEMBER 1 and 3: U.S.S.R. conducts another two tests.
NOVEMBER 7: Eisenhower voices concern over continued testing by the Soviet Union, declares that the U.S. is not obligated to stop nuclear weapons testing, but will abide by its current moratorium.

1959
U.S. HAS 15,468 STOCKPILED NUCLEAR WEAPONS; U.S.S.R. HAS 1060

JANUARY 19: U.S. and U.K. inform U.S.S.R. that they are no longer linking a ban on nuclear weapons testing to progress on major disarmament issues. Later that month the chairman of the A.E.C. proposes a graduated approach to nuclear test bans, beginning with a ban on more easily verified atmospheric tests and permitting underground and space testing until better monitoring methods are developed.
APRIL 13: Eisenhower proposes such a phased ban to Khrushchev; Khrushchev rejects proposal.
AUGUST 26: Eisenhower announces that the U.S. unilateral suspension of nuclear weapons testing of October 31, 1958 would be extended to December 31, 1959 and possibly beyond.
SEPTEMBER 18: Khrushchev asks the United Nations for complete disarmament of all countries in four years.

1960
U.S. HAS 20,434 STOCKPILED NUCLEAR WEAPONS; U.S.S.R. HAS 1605

FEBRUARY 13: France detonates the first of a total of 210 national nuclear tests in Reggane, Algeria, with a yield of 60–70 kilotons.
MARCH 19: Soviet delegates propose in Geneva a treaty banning for four to five years all tests in the atmosphere, the oceans, space, and underground above seismic magnitude 4.75.
MAY 1: U.S.S.R. shoots down a U.S. U-2 spy plane flying over Soviet territory and captures its pilot; U.S. overflights cease thereafter and the Cold War intensifies without U.S. aircraft reconnaissance of Soviet ICBM capability.
AUGUST: The U.S. deploys 18 nuclear Atlas ICBMs; within a year it deploys 39 more.
NOVEMBER 2: Democrat John F. Kennedy narrowly elected President of the United States, defeating Vice-President Richard M. Nixon.

1961
U.S. HAS 24,111 STOCKPILED NUCLEAR WEAPONS; U.S.S.R. HAS 2471

JANUARY 3: U.S. breaks off diplomatic relations with Cuba.
APRIL 12: Soviet Major Yuri Gagarin is the first man to orbit the Earth.
APRIL 18: U.S. and U.K. announce their readiness to immediately sign a completed draft Test Ban Treaty forbidding all atmospheric, space, ocean and underground tests down to a seismic threshold of 4.75.
MAY 5: U.S. astronaut Alan Shepard makes suborbital rocket flight of 302 miles.
JUNE: Khrushchev states to Kennedy at a U.S.–U.S.S.R. summit meeting in Vienna that anything less than full capitulation of West Berlin to East Germany would be seen as an "act of aggression" against the entire Warsaw Pact. Both superpowers begin a military escalation and tens of thousands of East German citizens flee to West Berlin. Khrushchev announces to the world that the Soviets now possess a 100-megaton bomb that would be "used against any aggressor."
JULY 26: Kennedy calls for governmental funding of nationwide fallout shelters and declares to the American people: "We cannot and will not permit the communists to drive us out of Berlin, either gradually or by force … If war begins, it will have begun in Moscow and not Berlin … Now in the thermonuclear age, any misjudgments on either side about the intentions of the other could rain more devastation in several hours than has been wrought by all the wars in human history."
SEPTEMBER 1: U.S.S.R. begins the first of 59 atmospheric nuclear weapons tests that year, breaking the voluntary test moratorium that had existed between the U.S. and U.S.S.R. for 34 months.
SEPTEMBER 5: President Kennedy announces that the U.S. will resume testing, but only underground.
SEPTEMBER 8: Berlin Wall completed.
SEPTEMBER 15: U.S. begins Operation *Nougat* at the Nevada Test Site; a total of 45 tests occur over the following 10 months, all but one underground.
OCTOBER 15: Khrushchev withdraws demand for West Berlin, ending the crisis. Only weeks before, Kennedy declines to act on the recommendation of his U.S. nuclear strategists to carry out a first, pre-emptive nuclear strike on the Soviet Union at an estimated cost of 3 to 15 million American lives.
OCTOBER 30: U.S.S.R. airdrops *Tsar Bomba*, at 57 megatons the world's largest nuclear explosion and over three times the size of the U.S.'s largest detonation. The bomb is built to deliver 100 megatons but is detuned for the test. Vociferous global protest ensues.
NOVEMBER 2: Kennedy declares that the U.S. is examining resumption of atmospheric testing.

1962
U.S. HAS 27,297 STOCKPILED NUCLEAR WEAPONS; U.S.S.R. HAS 3322

FEBRUARY 2: U.S.S.R. begins the first of 78 atmospheric nuclear weapons tests for the year, a Soviet record.
MARCH 2: Kennedy formally announces new U.S. atmospheric testing series. Total U.S. detonations for the year would number 96, the highest ever.
APRIL 25: U.S. Operation *Dominic* begins at Christmas Island; 30 atmospheric and 1 underwater detonations, cumulatively yielding 33.9 megatons; 22,600 military personnel attend.
JULY 3: Khrushchev meets in Moscow with Fidel Castro's brother, who requests defensive missiles for Cuba; Khrushchev accedes, but adds about 40 medium and long-range offensive nuclear ICBMs to the Cuban shipment, scheduled to be operational by October.
JULY 7: U.S. Operation *Sunbeam* begins at Nevada Test Site; four low-yield atmospheric detonations occur. Operation *Storax* begins at Nevada Test Site; all but one of its 48 tests will occur underground.
JULY 9: U.S. Operation *Fishbowl* begins at Johnston Island; five high-altitude atmospheric rocket tests occur, concluding on November 4.
AUGUST 5: U.S.S.R. airdrop-tests a 20.9 megaton thermonuclear device.
AUGUST 27: Kennedy and U.K. Prime Minister Macmillan propose to the U.N. Disarmament Committee a draft treaty containing proposals for an end to all nuclear testing in the atmosphere, underwater, and in outer space. This scheme would become the Limited Test Ban Treaty that was signed by the United States, the United Kingdom, and the Soviet Union 13 months later.
SEPTEMBER 25: U.S.S.R. airdrop-tests a 19.1 megaton thermonuclear device.
OCTOBER 14: U-2 spy plane photographs Soviet strategic ICBM installations in Cuba; three days later 32 sites are confirmed, all within a week of completion. Analysts estimate that targets as far away as Montana will shortly be in danger of nuclear attack.
OCTOBER 20: U.S. naval blockade of Cuba begins and all U.S. armed forces placed on high alert.
OCTOBER 22: Kennedy addresses the nation on the Soviet missile buildup in Cuba: "The purpose of these bases can be none other than to provide a nuclear strike capability against the Western Hemisphere", and anything fired from them will be considered a Soviet attack necessitating a "full retaliatory response." The two superpowers come as close as they ever have to a full-scale exchange of nuclear weapons, coining the popular term "brinksmanship."
OCTOBER 25: U.S. detonates *Bluegill Triple Prime*, a nuclear device mounted on a rocket, high over Johnston Island in the Pacific. U.S. also tests an ICBM over the Pacific the same day.
OCTOBER 28: U.S.S.R. fires three ICBMs to test their anti-ballistic-missile system.
OCTOBER 29: Backing down, Khrushchev messages Kennedy: "In order to eliminate as rapidly as possible the conflict which endangers the cause of peace … the Soviet Government … has given a new order to dismantle the arms which you described as offensive, and to crate and return them to the Soviet Union." Kennedy replies: "I think we should give priority to questions relating to the proliferation of nuclear weapons, on earth and outer space, and to the great effort for a nuclear test ban."
NOVEMBER 1: The U.S. and U.S.S.R. both conduct high-altitude nuclear tests on the same day.
NOVEMBER 4: Last U.S. atmospheric test occurs, *Tightrope*, above Johnston Island in the Pacific. The United States would go on to further conduct 751 deliberately contained nuclear tests underground until 1992, with an additional 5 uncontained cratering tests that purposefully breached the ground surface, and 4 zero-yield surface safety tests.
DECEMBER 24: U.S.S.R. airdrop-tests a 22 megaton device.
DECEMBER 25: Last U.S.S.R. atmospheric test occurs. The Soviet Union would go on to further conduct 494 nuclear tests underground until 1990.

1963
U.S. HAS 22,249 STOCKPILED NUCLEAR WEAPONS; U.S.S.R. HAS 4238

World radioactive fallout is the most intense in history.
JANUARY: U.S. deploys the underground silo-housed Titan II ICBM, ready to be fired on immediate notice, unlike previous ICBMs. Carrying a 9-megaton warhead, missiles are based at 54 sites in Arkansas, Nebraska and Arizona until retirement in 1987.
AUGUST 5: The Limited Test Ban Treaty is signed in Moscow by the United States, the United Kingdom and the Soviet Union, banning all nuclear testing in the atmosphere, oceans and outer space.
OCTOBER 7: U.S. Senate ratifies the treaty and President Kennedy signs, stating "The agreement itself is limited, but its message of hope has been heard and understood." The treaty is opposed by Republican Barry Goldwater, Lewis Strauss, former head of the Atomic Energy Commission, and thermonuclear impresario Edward Teller, who testifies before the Senate "If you ratify this treaty … you will have given away the future safety of this county."
NOVEMBER 23: President John F. Kennedy assassinated.

1964
U.S. HAS 30,751 STOCKPILED NUCLEAR WEAPONS; U.S.S.R. HAS 5221

AUGUST 7: U.S. Congress passes the Gulf of Tonkin Resolution, escalating American involvement in the Vietnam war.
NOVEMBER 16: China conducts the first of a total of 47 national nuclear tests at its Lop Nur proving ground, atmospherically detonating a uranium bomb with a yield of 22 kilotons.

1967
U.S. HAS 30,893 STOCKPILED NUCLEAR WEAPONS; U.S.S.R. HAS 8339

JUNE 17: China atmospherically detonates its first high-yield thermonuclear device at Lop Nur, yielding 3.3 megatons.

1968
U.S. HAS 28,884 STOCKPILED NUCLEAR WEAPONS; U.S.S.R. HAS 9399

AUGUST 24: France atmospherically detonates its first high-yield thermonuclear device, *Canopus*, at Fangataufa, Polynesia, yielding 2.6 megatons.

1969
U.S. HAS 26,910 STOCKPILED NUCLEAR WEAPONS; U.S.S.R. HAS 10,538

JULY 16–24: U.S. astronauts Neil Armstrong and Edwin "Buzz" Aldrin land on the Moon and return safely to Earth; their Saturn V rocket is designed by Wernher Von Braun, architect of the German V-2 missile and the Atlas, the first U.S. ICBM.

1970
U.S. HAS 26,119 STOCKPILED NUCLEAR WEAPONS; U.S.S.R. HAS 11,643

MARCH 5: Treaty on the Non-Proliferation of Nuclear Weapons, signed by the United States, the United Kingdom, China and the Soviet Union, enters into force for a duration of 25 years. France refuses to sign, but agrees to abide by its rules; by the mid-1980s over 120 nations had joined, with the notable exception of India and Pakistan.

1972
U.S. HAS 27,296 STOCKPILED NUCLEAR WEAPONS; U.S.S.R. HAS 14,478

MAY 26: U.S. President Richard Nixon and Soviet Chairman Leonid Brezhnev sign the Strategic Arms Limitation Treaty (SALT I) in Moscow, limiting each nation's number of nuclear delivery systems. They also sign the Anti-Ballistic Missile Treaty, limiting ABM defenses to the nations' capitals and one ICBM site. Signature of the ABM Treaty formalizes the principle of "mutually assured destruction" as a means to prevent nuclear war.

1973
U.S. HAS 28,335 STOCKPILED NUCLEAR WEAPONS; U.S.S.R. HAS 15,915

JANUARY 27: Four-party treaty is signed in Paris ending the Vietnam War.

1974
U.S. HAS 28,170 STOCKPILED NUCLEAR WEAPONS; U.S.S.R. HAS 17,385

MAY 18: India detonates a 10–15 kiloton nuclear device.
AUGUST 9: U.S. President Richard Nixon resigns under threat of Congressional impeachment.
SEPTEMBER 14: Last French atmospheric test.

DECEMBER: U.S. Atomic Energy Commission abolished, ending a long era of Cold War secrecy and duplicitous propaganda regarding nuclear testing, particularly atmospheric testing. The nuclear weapons functions of the A.E.C. are taken over by the Energy Research and Development Agency, ultimately replaced by the new U.S. Department of Energy in 1977.

1976
U.S. HAS 25,956 STOCKPILED NUCLEAR WEAPONS; U.S.S.R. HAS 21,205
MARCH 31: U.S. and U.S.S.R. agree to limit the maximum yield of underground nuclear test detonations to 150 kilotons.

1978
U.S. HAS 24,243 STOCKPILED NUCLEAR WEAPONS; U.S.S.R. HAS 25,393
U.S. President Jimmy Carter orders formerly-classified Atomic Energy Commission records to be made public.

1979
U.S. HAS 24,107 STOCKPILED NUCLEAR WEAPONS; U.S.S.R. HAS 27,935
JUNE 18: U.S. President Jimmy Carter and Soviet Premier Leonid Brezhnev sign SALT II Treaty, further limiting the number of nuclear delivery systems; Carter withdraws the treaty from Senate approval after the Soviets invade Afghanistan.

1980
U.S. HAS 23,764 STOCKPILED NUCLEAR WEAPONS; U.S.S.R. HAS 30,062
U.S. Congress, reviewing previously classified Atomic Energy Commission documents relating to radiation fallout on the continental United States declares: "The greatest irony of our atmospheric nuclear testing program is that the only victims of U.S. nuclear arms since World War II have been our own people."
OCTOBER 16: Last Chinese atmospheric test.

1982
U.S. HAS 22,937 STOCKPILED NUCLEAR WEAPONS; U.S.S.R. HAS 33,952
U.S. Congress establishes trust funds for environmental restoration of, and reparations to, the Marshall Island atolls of Bikini and Enewetak.

1983
U.S. HAS 23,154 STOCKPILED NUCLEAR WEAPONS; U.S.S.R. HAS 35,804
MARCH 23: U.S. President Ronald Reagan calls for a U.S. space-based missile defense system in the Strategic Defense Initiative. Popularly known as "Star Wars", SDI was immediately controversial and politicized, with some arguing that it was expensive, impractical, and a destabilizing acceleration of the arms race. Others argued that even an imperfect system would add stability and increase the deterrent effect of American weapons by protecting them for a second strike. Funding declined after the end of the Cold War and the collapse of the Soviet Union in 1991 and the system is never implemented.

1986
U.S. HAS 23,254 STOCKPILED NUCLEAR WEAPONS; U.S.S.R. HAS 40,723
Soviet Union stockpiles its greatest number of nuclear weapons.

1987
U.S. HAS 23,490 STOCKPILED NUCLEAR WEAPONS; U.S.S.R. HAS 38,859
DECEMBER 8: U.S. President Ronald Reagan and Soviet Premier Mikhail Gorbachev sign the Intermediate-Range Nuclear Forces Treaty (INF), phasing out all ground-launched intermediate and shorter-range nuclear missiles in Europe over a period of three years.

1988
U.S. HAS 23,077 STOCKPILED NUCLEAR WEAPONS; U.S.S.R. HAS 37,330
U.S. Congress directs the Department of Veterans Affairs to provide disability benefits to U.S. Nevada Test Site and Pacific Proving Grounds atomic veterans suffering from any of 13 types of cancer. Congress also sets up the Marshallese Nuclear Tribunal, allotting $270 million for compensation of indigenous radiation victims from Bikini and Enewetak Atolls.

1989
U.S. HAS 22,174 STOCKPILED NUCLEAR WEAPONS; U.S.S.R. HAS 35,817
NOVEMBER: Berlin Wall, built in 1961, falls amidst jubilation in Germany.

1990
U.S. HAS 21,211 STOCKPILED NUCLEAR WEAPONS; U.S.S.R. HAS 33,515
OCTOBER 15: U.S. President George H.W. Bush signs the Radiation Exposure Compensation Act, which formally apologises for the U.S. government's longstanding duplicity about the dangers of radiation fallout from its continental atmospheric nuclear testing program, and establishes a $100 million trust fund to aid victims directly downwind from the Nevada Test Site.
OCTOBER 24: Last U.S.S.R nuclear test to date.

1991
U.S. HAS 18,306 STOCKPILED NUCLEAR WEAPONS; U.S.S.R. HAS 29,606
FEBRUARY 23: U.S. leads coalition forces to drive Iraqi forces from Kuwait in the 4-day Persian Gulf War.
JULY 1: Warsaw Pact, formed in 1955, is dissolved.
JULY 31: U.S. President George H.W. Bush and Soviet Premier Mikhail Gorbachev sign the Strategic Arms Reduction Treaty (START I), an agreement to effect a two-thirds reduction in both nation's strategic nuclear forces from peak Cold War levels. Implementation is delayed for several years by the breakup of the Soviet Union and the economic difficulties of its successor states, but by the deadline of December 2001 Russia more than meets its treaty obligation. The threat of a nuclear war starting in Europe is vastly reduced.
NOVEMBER 26: Last U.K. nuclear test to date.
DECEMBER 26: Soviet Union collapses, leaving its nuclear weapons spread amongst the newly-separate states of Russia, Belarus, Kazakhstan and the Ukraine. Six years later, the last of the former Soviet nuclear weapons are finally moved to Russia, which remains the only nuclear power of the former Soviet states.

1992
U.S. HAS 13,731 STOCKPILED NUCLEAR WEAPONS; RUSSIA HAS 26,256
SEPTEMBER 23: Last U.S. nuclear test to date.

1993
U.S. HAS 11,536 STOCKPILED NUCLEAR WEAPONS; RUSSIA HAS 22,785
JANUARY 3: U.S. President George H.W. Bush and Russian President Boris Yeltsin sign the START II Treaty, providing for even deeper cuts in both nation's strategic nuclear arms stockpile than those of START I.

1995
U.S. HAS 10,953 STOCKPILED NUCLEAR WEAPONS; RUSSIA HAS 15,615
MAY 12: The Treaty on the Non-Proliferation of Nuclear Weapons, having been in force for 25 years, is extended indefinitely by vote of the United Nations.

1996
U.S. HAS 10,886 STOCKPILED NUCLEAR WEAPONS; RUSSIA HAS 12,722
JANUARY 26: U.S. Senate ratifies START II Treaty.
JANUARY 27: Last French nuclear test to date.
JULY 29: Last Chinese nuclear test to date.
SEPTEMBER 24: United States, United Kingdom, France, China, Russia and numerous other nations sign the Comprehensive Nuclear Test Ban Treaty, agreeing to completely cease all testing of nuclear weapons. Forty-four specific nations must sign and ratify for the treaty to come into force; as of December 31, 1997, the crucial nations of India, Pakistan and North Korea had not signed.

1998
U.S. HAS 10,763 STOCKPILED NUCLEAR WEAPONS; RUSSIA HAS 10,764
MAY 11–15: India detonates five nuclear devices in two underground tests at its Pokhran test site. Total yield is 57.9 kilotons.
MAY 28–30: Pakistan detonates from three to five nuclear devices in two underground tests at its Chagai test site. Total yield is 55–63 kilotons.
OCTOBER 31: U.S. Senate votes not to ratify the Comprehensive Nuclear Test Ban Treaty, citing concerns over ability to safely maintain the nuclear stockpile over time without testing.

2000
U.S. HAS 10,615 STOCKPILED NUCLEAR WEAPONS; RUSSIA HAS 10,201
APRIL 14: Russian Duma ratifies the START II Treaty, set to take effect December 31, 2007.
JUNE 30: Russian Duma ratifies the Comprehensive Nuclear Test Ban Treaty.
NOVEMBER: Republican George W. Bush elected to U.S. presidency after losing the popular vote to Democratic Vice-President Al Gore.

2001
U.S. HAS 10,491 STOCKPILED NUCLEAR WEAPONS; RUSSIA HAS 9126
SEPTEMBER 11: Operatives of the Afghanistan-based Al Qaeda terrorist group hijack four commercial airliners and crash one into the U.S. Pentagon in Washington, and one into each of the two towers of the World Trade Center in New York, bringing both towers down. The fourth suicide plane crashes in Pennsylvania after a passenger-initiated struggle.
SEPTEMBER 20: President George W. Bush declares in an address to Congress and the American people: "Our war on terrorism begins with Al Qaeda but does not end there," inaugurating "a lengthy campaign, unlike any other we have ever seen … From this day forward, any nation that continues to harbor or support terrorism will be regarded as a hostile regime."
OCTOBER 7: U.S. begins air strikes on Afghanistan, toppling the fundamentalist Islamic Taliban regime that has provided safe haven to the Al Qaeda leadership.
DECEMBER 14: The Bush administration unilaterally withdraws from the Anti-Ballistic Missile Treaty of 1972 and advocates placement of a rudimentary anti-ballistic missile defense system in California and Alaska from 2003 to 2008, weakening the concept of mutual deterrence.

2002:
U.S. HAS 10,455 STOCKPILED NUCLEAR WEAPONS; RUSSIA HAS 8579
JANUARY: Nuclear-power adversaries India and Pakistan come to the brink of war over the disputed territory of Kashmir. India has between 30 and 35 nuclear weapons and Pakistan has between 24 and 48.
FEBRUARY: The Bush Administration completes its Congressionally-mandated Nuclear Posture Review, broadly outlining an expansionist nuclear policy and infrastructure for the next decade in a clear break from U.S. policy since 1992. A new intercontinental ballistic missile is seen for deployment by 2018, a new submarine-launched ballistic missile by 2030, and a new heavy bomber by 2040. Arguing for a new approach to nuclear warfare, the *Review* emphasizes the development of so-called "bunker-buster" nuclear weapons for "hardened and deeply-buried targets" and "agent defeat weapons" for attacking chemical and biological warfare sites. The *Review* calls for a revitalized nuclear weapon research and development complex throughout the country, and advocates a thorough revamping of the Nevada Test Site facilities to reduce the current 2–3 year period required to resume nuclear testing. Not since the first term of the Reagan Administration are nuclear weapons so emphasized in U.S. defense strategy.
MAY: U.S. and Russian Presidents George W. Bush and Vladimir Putin sign an agreement, known as the Strategic Offensive Reductions Treaty, to reduce strategic warhead stockpiles from 6000 warheads to between 1,700–2,200 warheads each by 2012 – essentially the same levels outlined by the START II Treaty and the current U.S. Nuclear Posture Review. The agreement's informal nature renders it not legally-binding in the sense of a true treaty.

2003
JANUARY: North Korea, suspected already of possessing one or two nuclear weapons, embarks on a resuscitation of its nuclear weapons program, inactive since 1994, in violation of its participation in the Non-Proliferation Treaty. Short-term production of five or six nuclear weapons is expected.

BIBLIOGRAPHY

While the emphasis of this book is on visual photographic documentation, many writers and investigators have spent lifetimes making sense of a particularly challenging subject. That much of the information surrounding it has been, or remains, deliberately kept secret by the United States government makes their tenacity even more impressive. Works that were particularly helpful to this book's textual research have been marked with an asterisk.

Alperovitz, Gar
 The Decision to Use the Atomic Bomb. New York, Alfred A. Knopf, 1995.

Ball, Howard
 Justice Downwind: America's Atomic Testing Program in the 1950s. New York, Oxford University Press, 1986.

Boyer, Paul
 By The Bomb's Early Light: American Culture and Thought at the Dawn of the Atomic Age. New York, Pantheon, 1986.

Carlisle, Rodney P. (ed.)
 **Encyclopedia of the Atomic Age.* New York, Facts on File, 2001.

Coolidge, Matthew
 The Nevada Test Site: A Guide to America's Nuclear Proving Ground. Los Angeles, Center for Land Use Interpretation, 1996.

Del Tredici, Robert
 **At Work In The Fields of The Bomb.* New York, Harper & Row, 1987.

Dyson, Freeman
 Disturbing the Universe. New York, Harper & Row, 1979.

Else, Jon (director)
 The Day After Trinity. Film, 89 minutes, VHS/DVD, Image Entertainment, 1981.

Fermi, Rachel and Esther Samra
 Picturing the Bomb: Photographs from the Secret World of the Manhattan Project. New York, Harry N. Abrams, 1995.

Frisch, Otto
 What Little I Remember. New York, Cambridge University Press, 1979.

Gallagher, Carole
 **American Ground Zero: The Secret Nuclear War.* New York, Random House, 1993.

Garnett, Joy (ed.)
 The Bomb Project. www.firstpulseprojects.net/bombproject, 1997–present.

Goin, Peter
 Nuclear Landscapes. Baltimore, Johns Hopkins Press, 1991.

Groves, Leslie R.
 Now It Can Be Told: The Story of the Manhattan Project. New York, Harper & Brothers, 1962.

Hansen, Chuck
 U.S. Nuclear Weapons: The Secret History. Aerofax/Orion Books, 1988.
 **The Swords of Armageddon: U.S. Nuclear Weapons Development since 1945.* (CD-ROM) Sunnyvale, CA, Chukelea Publications, 2001.

Hersey, John
 Hiroshima. New York, Knopf, 1946/1985.

Keegan, John
 The Second World War. New York, Penguin, 1988.

Kennan, George
 Memoirs, 1925–1950. Pantheon, 1967.

Khrushchev, Nikita
 Khrushchev Remembers. New York, Little, Brown, 1990.

Kuran, Peter (director)
 **Trinity and Beyond: The Atomic Bomb Movie.* Film, 60 minutes, VHS/DVD. Visual Concept Entertainment, 1995.
 **Nukes In Space: The Rainbow Bombs.* Film, 60 minutes, VHS/DVD. Visual Concept Entertainment, 1999.
 **Atomic Journeys: Welcome to Ground Zero.* Film, 60 minutes, VHS/DVD. Visual Concept Entertainment, 1999.
 **Nuclear Rescue 911: Broken Arrows & Incidents.* Film, 53 minutes, VHS/DVD. Visual Concept Entertainment, 2000.

Jones, Rodney W. et al.
 Tracking Nuclear Proliferation: A Guide in Maps and Charts. Washington D.C., Carnegie Endowment for International Peace, 1998.

Jungk, Robert K.
 Brighter than a Thousand Suns: A Personal History of the Atomic Scientists. New York, Harcourt Brace Jovanovich, 1958.

LeMay, Curtis E., with MacKinlay Kantor
 Mission with LeMay: My Story. New York, Doubleday, 1965.

Lifton, Robert Jay, and Greg Mitchell
 Hiroshima in America: A Half Century of Denial. New York, Putnam, 1995.

Loader, Jayne and Pierce Rafferty (directors)
 The Atomic Café. Film, 88 minutes, VHS/DVD. New Video Group, 1982.

May, Ernest R. and Philip D. Zelikow
 The Kennedy Tapes: Inside the White House During the Cuban Missile Crisis. Belknap Press, 1997.

McPhee, John.
 **The Curve of Binding Energy.* New York, Farrar, Straus & Giroux, 1974.

Mikhailov, V. N., ed.
 **Catalog of Worldwide Nuclear Testing.* New York, Begell-Atom, 1999.

Miller, Richard
 **Under the Cloud: The Decades of Nuclear Testing.* New York, The Free Press, 1986.

Oe, Kenzaburo
 Hiroshima Notes. Tokyo, Iwanami Shoten, 1965/New York, Grove Press, 1996.

Oppenheimer, Robert
 Letters and Recollections. Stanford, Stanford University Press, 1980.

Powers, Thomas
 Heisenberg's War: The Secret History of the German Bomb. New York, Alfred A. Knopf, 1993.

Rhodes, Richard
 **Dark Sun: The Making of the Hydrogen Bomb.* New York, Simon & Schuster, 1995.
 **The Making of the Atomic Bomb.* New York, Simon & Schuster, 1986.

Sahkarov, Andrei
 Memoirs. New York, Alfred A. Knopf, 1990.

Seaborg, Glenn T. and Benjamin S. Loeb
 Kennedy, Khrushchev and the Test Ban. Berkeley, University of California Press, 1981.

Shelton, Frank H.
 **Reflections of a Nuclear Weaponeer.* Colorado Springs, Shelton Enterprise, 1988.

Solnit, Rebecca
 **Savage Dreams: A Journey into the Hidden Wars of the American West.* San Francisco, Sierra Club Books, 1994.

Sublette, Carey and Gary Au, eds.
 **The High Energy Weapons Archive.* http://nuketesting.enviroweb.org/hew, 1994–present.

Szilard, Gertrud W. and Spencer R Weart (eds.)
 Leo Szilard: His Version of the Facts. Cambridge, MA: MIT Press, 1978.

Takaki, Ronald T.
 Hiroshima: Why America Dropped the Bomb. Back Bay Books, 1996.

Titus, Costandina A.
 Bombs in the Backyard: Atomic Testing and American Politics. Las Vegas, University of Nevada Press, 1987.

Treat, John W.
 Writing Ground Zero: Japanese Literature and the Atomic Bomb. Chicago, University of Chicago Press, 1996.

U.S. Department of Energy
 **United States Nuclear Tests: July 1945 through September 1992.* Las Vegas, DOE/NV-209-REV 15, 2000.

Walker, Gregory (ed.)
 Trinity Atomic Web Site. http://nuketesting.enviroweb.org, 1995–present.

Weart, Spencer R.
 Nuclear Fear: A History of Images. Cambridge, Harvard University Press, 1988.

Weale, Adrian
 Eye-Witness Hiroshima. Carroll & Graf Publishers, 1995.

Williams, Terry Tempest
 Refuge: An Unnatural History of Family and Place. New York, Pantheon, 1991.

Yamahata, Yosuke
 Nagasaki Journey. Rohnert Park, California, Pomegranate Artbooks, 1995.

ACKNOWLEDGEMENTS

I am profoundly grateful to my studio assistant and friend Laura Heyman (www.lauraheyman.net), whose tenacious research, honed eye, and generous creative judgment helped produce this effort. David Vigil, Asha Schechter, Kaiko'o Victor, and Eirik Johnson have ably followed in her footsteps, and I thank them for their extensive work on this project.

At the still-picture branch of the United States National Archives at College Park, Maryland, head archivist Kate Flaherty was unfailingly helpful during all aspects of research at that great institution, as were her staff members Theresa Roy and Sharon Culley. Roger Meade, chief archivist at the Los Alamos National Laboratory in New Mexico, went above the call of duty to make material available and help identify some of its more arcane aspects. At Lawrence Livermore National Laboratory in California, archivists Steve Wofford, Beverly Bull and Maxine Trost helped with image research. Nick Broderick, classification analyst at Lawrence Livermore, kindly provided final identification of notoriously difficult to attribute ultra-high-speed *Rapatronic* images made by E.G.& G. Thanks as well to filmmaker Peter Kuran for additional identification help with *Rapatronic* images.

For their early support of this work in both book and installation form, special thanks to Hosfelt Gallery in San Francisco, Craig Krull Gallery in Santa Monica, Catherine Edelman Gallery in Chicago, Frehrking+Wiesehöfer Gallery in Cologne, Eriko Osaka of Art Tower Mito in Japan, Martin Caiger-Smith and Susan Brades of the Hayward Gallery in London, Hélène Kelmachter and Hervé Chandès of the Fondation Cartier pour l'Art Contemporaine in Paris, and Christoph Schaden of the Museum Schloss Moyland in Germany.

To my friends and family, who have attended this investigation with cheerful and generous support, thank you. For all their various contributions, especially pointed appreciation is due to Rebecca Solnit, Oliver Morton, Jack Woody, Mark Klett, David Rattray, Michael Rauner, Catherine Harris, Christopher Sharpe, Paul Catasus, Pauline Shaver, and Deborah Light.

No person is more important to *100 SUNS* than my editor Mark Holborn, whose vision and skill at Jonathan Cape in London have made this book an international fact, and continue to inspire my worklife on a daily basis. Sonny Mehta at Knopf supported this book from the start, and I am profoundly grateful to him and my New York editor Shelley Wanger for such a strong commitment to the American edition. Neil Bradford, Production Director at Jonathan Cape, Catherine Graham, Senior Rights Manager at Random House UK, and Friederike Huber, designer, all deserve applause. Thanks, as well, to the distinguished publishing houses in France, Germany, Italy and Sweden that have chosen to release *100 SUNS* in translation.

www.100suns.info

ALL PHOTOGRAPHS COURTESY THE UNITED STATES NATIONAL ARCHIVES AND THE LOS ALAMOS NATIONAL LABORATORY

DIGITAL IMAGE PROCESSING BY MICHAEL LIGHT
RESEARCH ASSISTANCE BY LAURA HEYMAN
EDITED WITH THE ASSISTANCE OF MARK HOLBORN
PRODUCTION AND DIRECTION BY MARK HOLBORN AND NEIL BRADFORD
DESIGN BY MICHAEL LIGHT

The research cited and observations expressed in *100 SUNS* are those of the author, not those of the United States National Archives or the Los Alamos National Laboratory.

THIS IS A BORZOI BOOK
PUBLISHED BY ALFRED A. KNOPF

Copyright © 2003 by Michael Light
Printed from digital images copyright © 2003 by Michael Light

All rights reserved under International and Pan-American Copyright Conventions. Published in the United States by Alfred A. Knopf, a division of Random House, Inc., New York, and simultaneously in Canada by Random House of Canada Limited, Toronto. Distributed by Random House, Inc., New York.

www.aaknopf.com

Published simultaneously in Great Britain by Jonathan Cape, Random House, London.

Knopf, Borzoi Books, and the colophon are registered trademarks of Random House, Inc.

ISBN 1-4000-4113-9

Printed and bound in China by C&C Offset Printing Co. Ltd

First American Edition Published October 24, 2003
Second Printing, September 2006